CENTRAL VALLEY

COSTA RICA **REGIONAL GUIDES**

Diego Arguedas Ortiz and Luciano Capelli

AN OJALÁ EDICIONES & ZONA TROPICAL PUBLICATION

from

COMSTOCK PUBLISHING ASSOCIATES

an imprint of

CORNELL UNIVERSITY PRESS

ITHACA AND LONDON

First published 2020 by Cornell University Press

Printed in China

Library of Congress Cataloging-in-Publication Data

Names: Arguedas Ortiz, Diego, author. | Capelli, Luciano, author.
Title: Central Valley / Diego Arguedas Ortiz and Luciano Capelli.
Description: Ithaca [New York] : Comstock Publishing Associates, an imprint
of Cornell University Press, 2020. | Series: Costa Rica reigonal guides
| "An Ojalá Ediciones & Zona Tropical publication."
Identifiers: LCCN 2020015074 | ISBN 9781501752834 (paperback)
Subjects: LCSH: Central Valley (Costa Rica)—Description and travel.
Classification: LCC F1549.C4 A74 2020 | DDC 917.2/86--dc23
LC record available at https://lccn.loc.gov/2020015074

Front cover photo: Luciano Capelli
Back cover photo: Jeffrey Muñoz

COSTA RICA REGIONAL GUIDES

The world knows Costa Rica as a peaceful and environmentally conscious country that continues to attract several million tourists a year, yet this image may obscure a social and biological legacy that very few visitors get to know.

We hope that the six books in this collection will reveal a reality beyond the apparent one. These are meant to pique the curiosity of travelers through stories about nature, geology, history, and culture, all of which help explain Costa Rica as it exists today.

Each title is dedicated to those who fought, and continue to fight, with grace and wisdom, for a natural world that lies protected, in a state of balance, and accessible to all—in other words, one that is closer to the ideal we seek to make real.

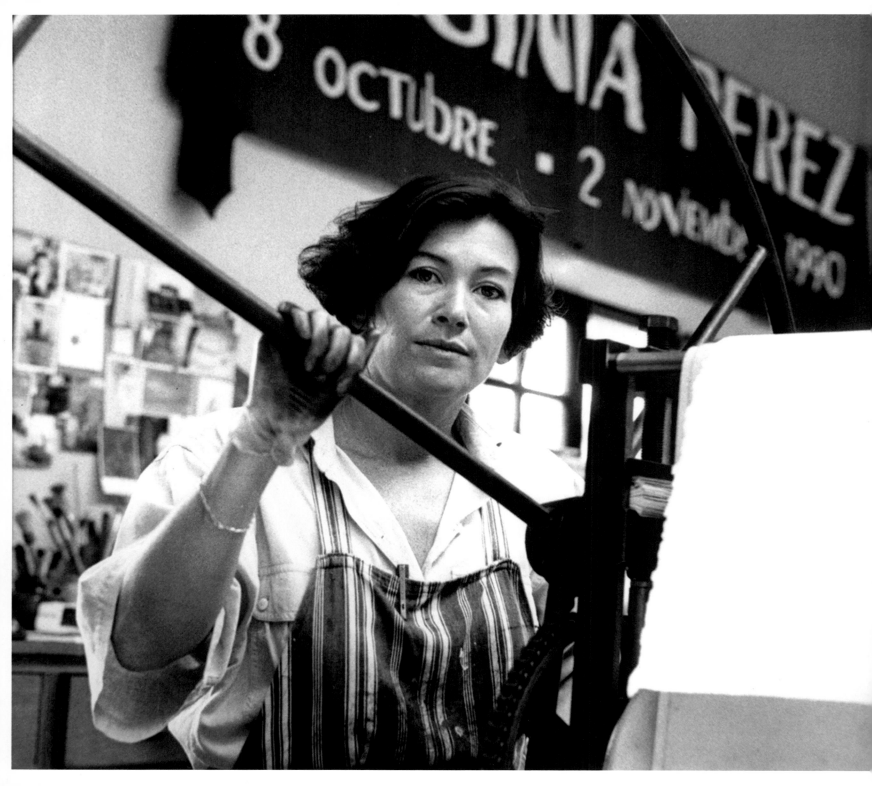

DEDICATION
VIRGINIA PÉREZ-RATTÓN

Virginia Pérez-Rattón received the National Culture Award in 2010 for her tireless efforts to foment cultural and artistic production in Costa Rica, indeed in greater Central America. In an interview at the time, she confessed that one of her chief gratifications came from being able to live her life as a "creative act." Through tact and great charisma, she managed to bring together communities of people involved in artistic pursuits in Central America.

As the first director of the Museum of Contemporary Art and Design, she broke down barriers that had hindered creative endeavors in the past and helped to turn San José into an exemplary model for how government and citizens can cooperate to create a richer cultural life.

Eloquent, enthusiastic, caring, multifaceted, and, yes, subversive: these words sum up someone ideally suited to lead the charge for a cultural renaissance—and Virginia was all of those things and more. In 1999 she created TEOR/éTica, a gallery, a research project, and a forum for disseminating information about artistic trends—today one of the most dynamic and innovative cultural projects in Latin America.

Before Virginia died, her sister had suggested that the following phrase be posted on the façade of TEOR/éTica: Nadie te quita lo bailado, loosely "No one can take away from you the things you have enjoyed." In a charming neighborhood in this small city, you can visit the gallery, a place that has transformed the cultural life of the Central Valley forever.

Juan Ignacio Salom

CONTENTS

LAND OF FIRE

P 1

THE "GOLDEN BEAN"

P 49

CITIES OF THE VALLEY

P 87

INDEX

P 119

CREDITS

P 121

CENTRAL VALLEY

COSTA RICA 〜〜〜 REGIONAL GUIDES

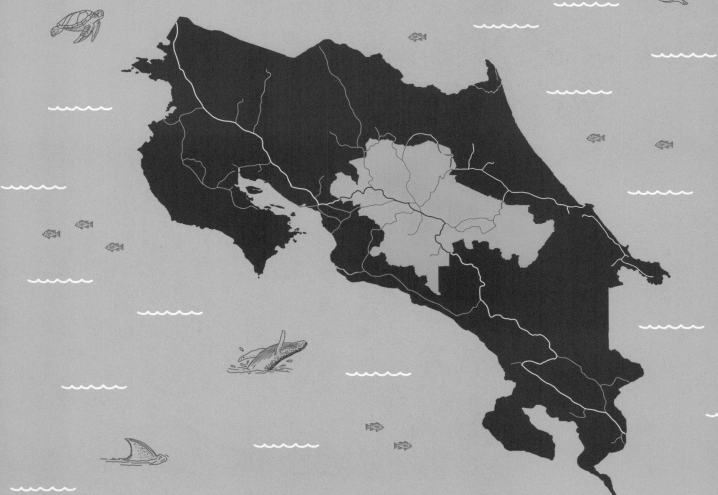

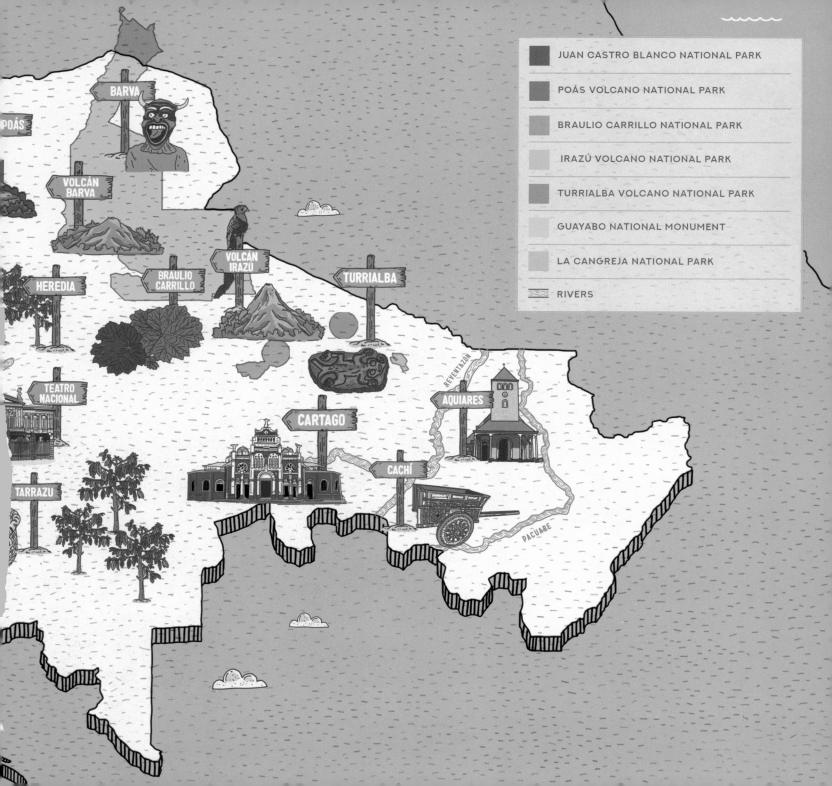

POÁS

BARVA

VOLCÁN
BARVA

HEREDIA

BRAULIO
CARRILLO

VOLCÁN
IRAZÚ

TURRIALBA

TEATRO
NACIONAL

REVENTAZÓN

AQUIARES

CARTAGO

CACHÍ

TARRAZU

PACUARE

JUAN CASTRO BLANCO NATIONAL PARK

POÁS VOLCANO NATIONAL PARK

BRAULIO CARRILLO NATIONAL PARK

IRAZÚ VOLCANO NATIONAL PARK

TURRIALBA VOLCANO NATIONAL PARK

GUAYABO NATIONAL MONUMENT

LA CANGREJA NATIONAL PARK

RIVERS

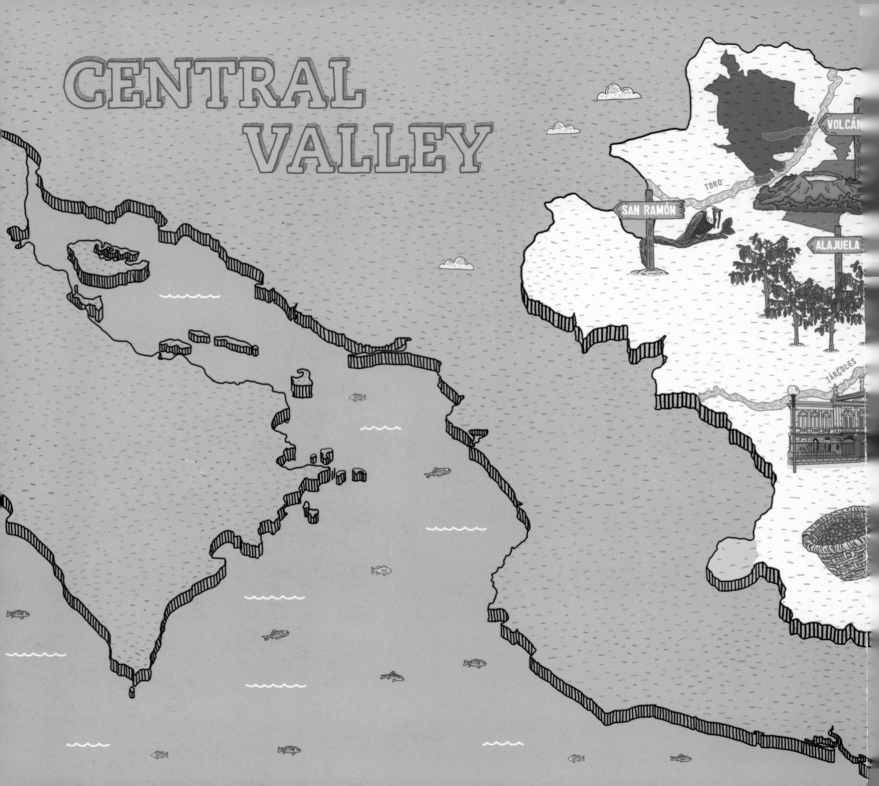

CENTRAL VALLEY

VOLCÁN

TORO

SAN RAMÓN

ALAJUELA

TÁRCOLES

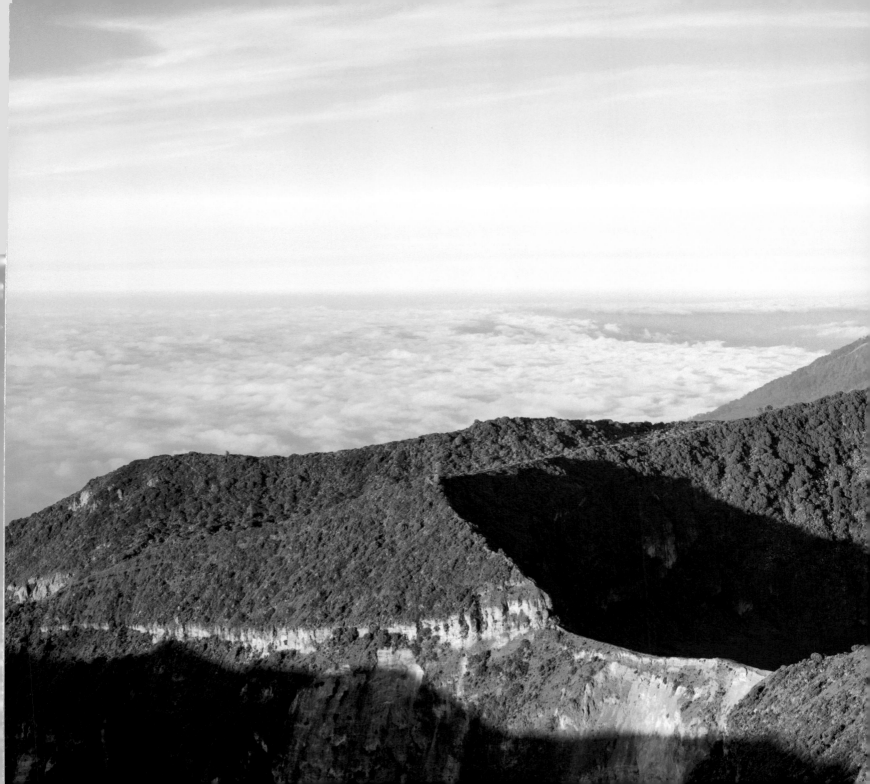

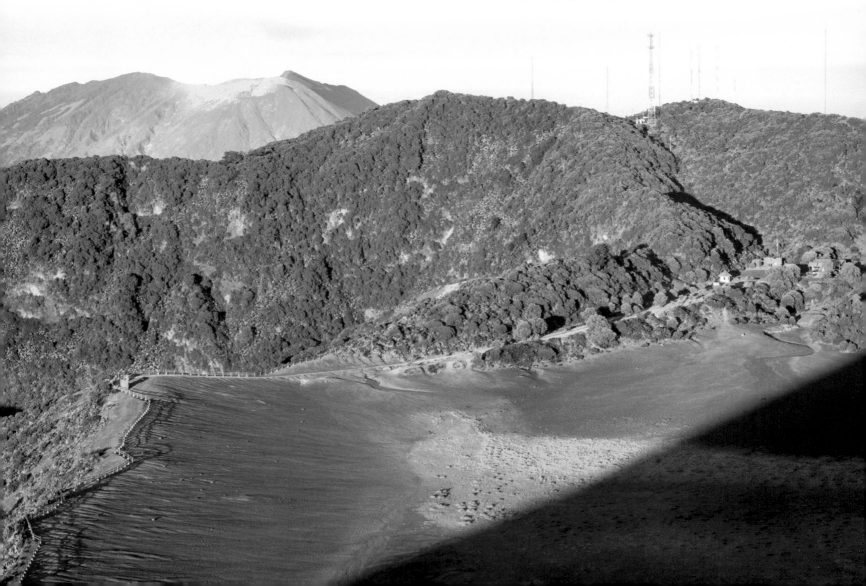

LAND OF
FIRE

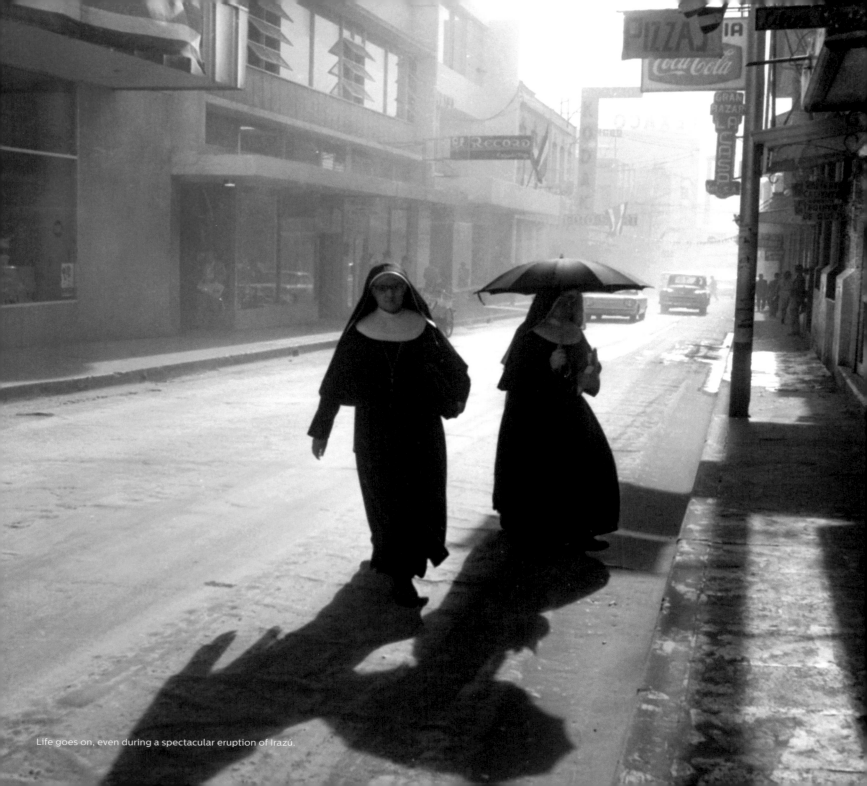

Life goes on, even during a spectacular eruption of Irazú.

In 1970, a group of young people set their sights on the volcano. In his office in the National Parks Department, newly created as part of the Ministry of Agriculture and Livestock, Mario Boza and his colleagues had hatched a plan. For a decade and a half, the lands surrounding the crater of Poás Volcano had been in the hands of the Costa Rican Tourism Institute, but the twenty-year-old Boza knew that this was the ideal place to create Costa Rica's first national park.

Just a year earlier, in 1969, Boza's master's thesis had presented a management plan for this hypothetical park, at a time when the very concept of a national park was a novelty in the country. To Boza, the location of the proposed park seemed ideal—it was near Alajuela, a large city, offered access year-round to the edge of the crater, and housed valuable ecosystems that required protection. When the Legislative Assembly approved the Forestry Law and created the National Parks Department, Boza was appointed its first director. He entered his new office with this plan for the heist already formed

Poás Volcano National Park was inaugurated in January 1971. It started up with a single employee—the conservation and monitoring work was performed by volunteers—yet things were now in motion. The country had it first national park and tourists were beginning to arrive.

Poás is distinguished by the magnitude of its crater, which some call the largest in the world. Others bicker, claiming it is merely the widest. Whatever the case may be, few craters with such a diameter (4330 feet / 1320 meters in a north-south direction) permit car access practically to the edge.

People commented on the beauty of Poás since the end of the 19th century, when the renowned Swiss geographer Henri Pittier called for its protection. Although the government tried to create access to the crater at the start of the new century, the resulting path was barely fit for riders on horseback. In 1930, two stubborn locals hired a group of farmworkers and set off toward the volcano in a 1929 Chevrolet. It took them 15 days to reach the crater, through muddy stretches and other obstacles, and at times they resorted to pushing the car. Here was proof of concept, of a sort. "Poás Volcano will probably be one of the most visited places in the world by tourists, as soon as there is a good road," historian Miguel Obregón Loría would write two years later in his *General Geography of Costa Rica*.

The Costa Rican Tourism Institute (ICT) was created in 1955. It was given stewardship of the lands lying within a radius of 1.25 miles (2 km) from the craters of every volcano in the country. The road to Poás was improved in stages and by 1968 the route was accessible to all types of vehicles, throughout the year. Today, the volcano is the second most visited park in Costa Rica, and it receives more international tourists than any other place in the country.

The situation is quite different with Irazú Volcano, which lies east of the Central Valley. There, three out of four visitors are Costa Ricans. Of the peaks that exceed 10,000 feet (3000 m), this is the one that is closest to the capital city of San José. Although it neighbors population centers, Irazú is a benign presence in a country in which, for the most part, volcanoes are appreciated, not feared. In the Central Valley of the country, it is perfectly common to wake up one morning and see a gray column of ash issuing forth from one of the nearby peaks.

However unthreatening, Irazú did disrupt, relatively recently, daily life in parts of the Central Valley—for two years! It coincided with an iconic moment in Costa Rican history. On March 18, 1963, US President John Kennedy visited the country, just a few days after the volcano erupted. Although the ash did little to disrupt his visit, it continued to fall well after his departure. Grandparents in San José and Cartago still remember carrying umbrellas to protect themselves from airborne particles and recount how people climbed on the roofs of homes to clean out rain gutters. Young children played with the ash as though it were sand on a beach.

The relaxed attitude that Ticos have toward their volcanoes can be explained in part by their proximity. Simply put, people have become habituated to them. The colonial capital, Cartago, was born and grew under the shelter of Irazú, and when the new republic transferred the capital to San José, further west, it too lay within sight of volcanoes. Historical chronicles of colonial times and the first years of the republic make mention of these peaks and eruptions, and the challenges they posed for governance.

But the connection between human activity and volcanic forces goes back even further in time, to the Pre-Columbian era. The Botos people were living on the slopes of Poás and Barva volcanoes when the Spanish arrived. The name *Irazú* seems to come from an indigenous town that in 1569 was located on the slopes of the volcano, then called Istarú, which meant "hill of trembling and thunder."

Although we humans tolerate a little ash now and then, our machines cannot. From 2014 to 2019, Turrialba Volcano, the easternmost of all, began to spew ash sufficient to shut down the San José international airport. Of the four volcanoes in the Central Valley—Poás, Barva, Irazú, and Turrialba—it is the latter that has created a bit of havoc in recent years. Ash can enter the engines of jets and potentially create problems. For a country that depends on tourism, that is bad news indeed.

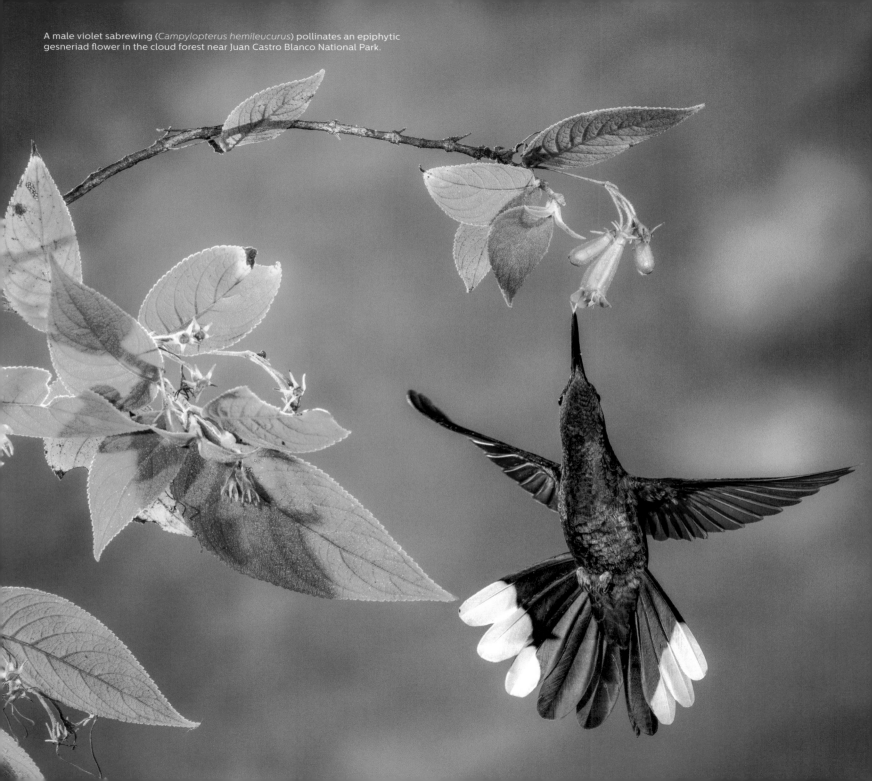

A male violet sabrewing (*Campylopterus hemileucurus*) pollinates an epiphytic gesneriad flower in the cloud forest near Juan Castro Blanco National Park.

At 10,960 feet (3340 m), Turrialba is the second tallest volcano in Costa Rica. Like Poás and Irazú, it first came under protection in 1955, with the creation of ICT. But while the other two peaks quickly became fixtures on the tourist trail, Turrialba did not. It is farther away from San José and getting to its summit requires a steep hike up a trail that turns treacherous at a point about 4 miles (7 km) from the top. That said, the spectacular view from the summit is reward enough for the arduous walk.

The fourth great volcano of the Central Valley, Barva, did not initially come under the protection of ICT. Less noticeable than its siblings, this shy peak hides a secret under its skirts, a liquid treasure. On the southern slope of Barva are the aquifers that provide drinking water to the greater metropolitan area and other regions of the country.

The inactivity on Barva—to all appearances a lazy codger who has been asleep for several thousand years—gave time for oaks, mosses, and orchids to flourish. The lush deep green vegetation that surrounds the inactive crater—a lagoon filled with blueish water—creates a fairytale world. While many of the slopes of the Central Mountain Range, which is formed by a series of volcanic peaks, have been stripped bare by agriculture, not so here.

On the heights of Barva and the other volcanoes of the Central Valley, one senses a special aura, an ineffable mood. The road to the summits, through dairy farms and fields of potatoes, signals that the city has been left behind. Weekend journeys are an old tradition among Costa Ricans, who make a pilgrimage every so often to verify that nothing has changed; they find the same views, the same flora, and the same misty air. In these spaces time dilates, though in geological terms, there is a mere flicker between the creation of the volcanoes and the lives of those visiting them on any given day.

From the top of Poás, Álvaro Ugalde had a revelation. While he—along with Mario Boza—would end up being father of the Costa Rican national parks system, in 1973 he had resigned himself to staying at his current job as administrator of Santa Rosa National Park until his retirement. But then, by good fortune,

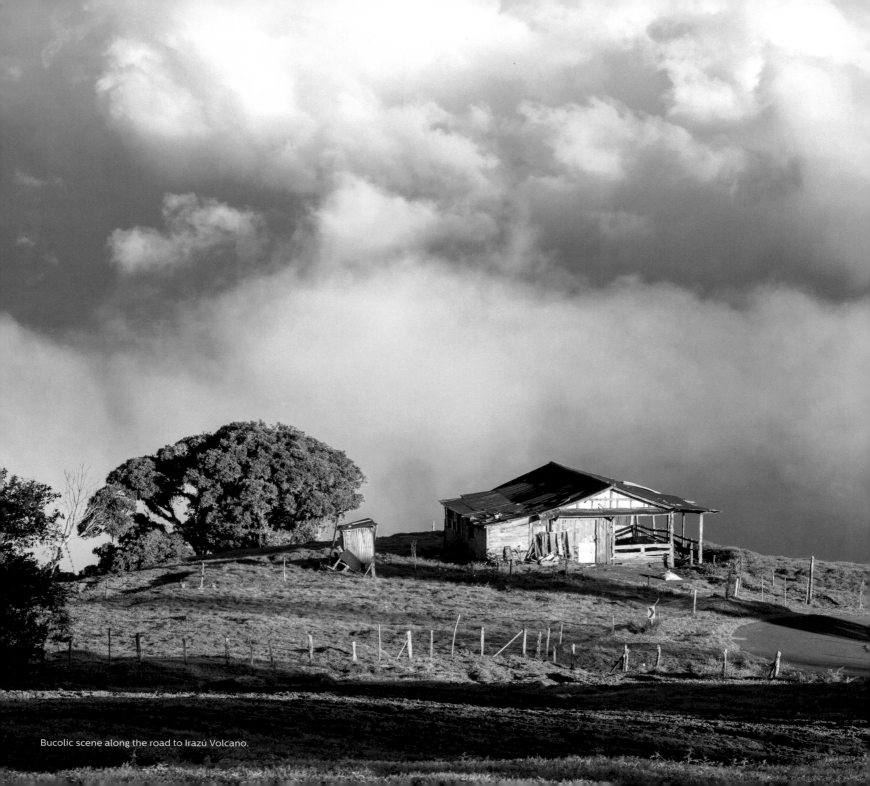

Bucolic scene along the road to Irazú Volcano.

the hardheaded Ugalde came into disfa-vor with a government minister, and he was "exiled" to Poás. Just 27-years-old, the event would transform his life.

"From the summits one sees better and therefore my passage through Poás Vol-cano produced in my mind a miracle or a radical change," Ugalde wrote. From that island among the clouds, Ugalde saw other volcanoes around it, Bajo del Toro, the greenery of Sarapiquí, and the two oceans. "I went from seeing myself getting older in Santa Rosa to seeing a country that needed a system of national parks and not just a park or two," he recalls. At the top of Poás, a spirit was born that would forge and consolidate the system of protected areas in the coming decades.

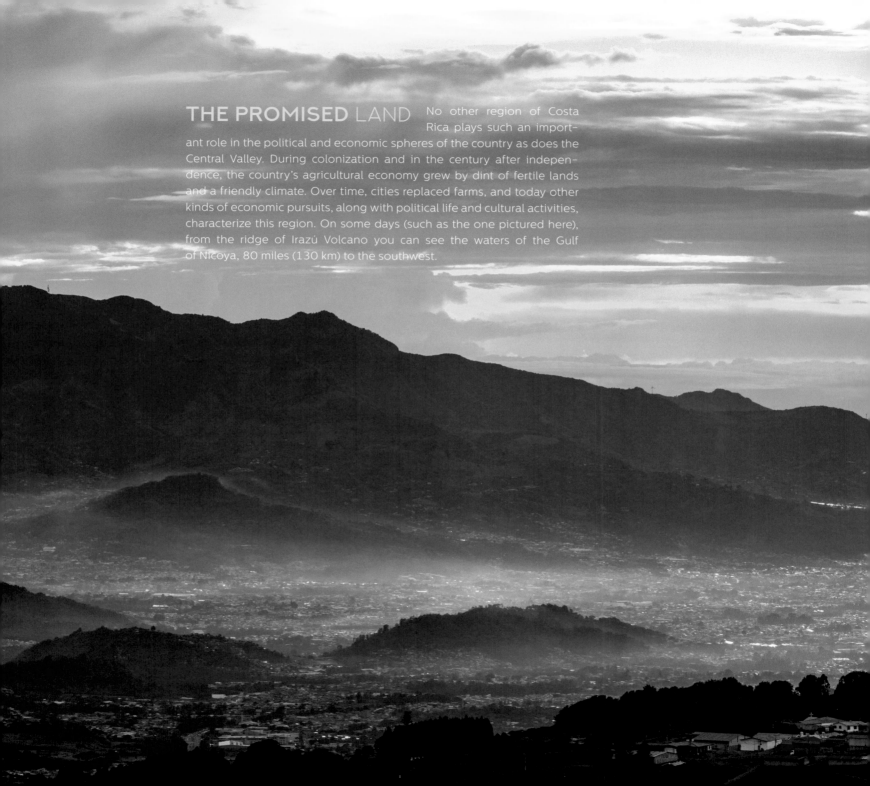

THE PROMISED LAND No other region of Costa Rica plays such an important role in the political and economic spheres of the country as does the Central Valley. During colonization and in the century after independence, the country's agricultural economy grew by dint of fertile lands and a friendly climate. Over time, cities replaced farms, and today other kinds of economic pursuits, along with political life and cultural activities, characterize this region. On some days (such as the one pictured here), from the ridge of Irazú Volcano you can see the waters of the Gulf of Nicoya, 80 miles (130 km) to the southwest.

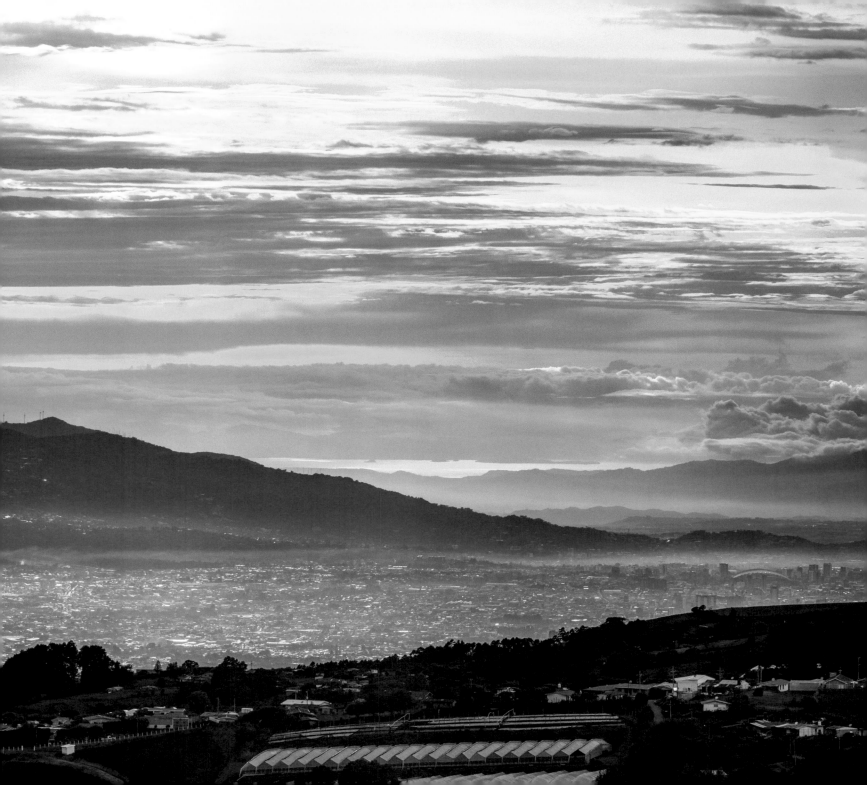

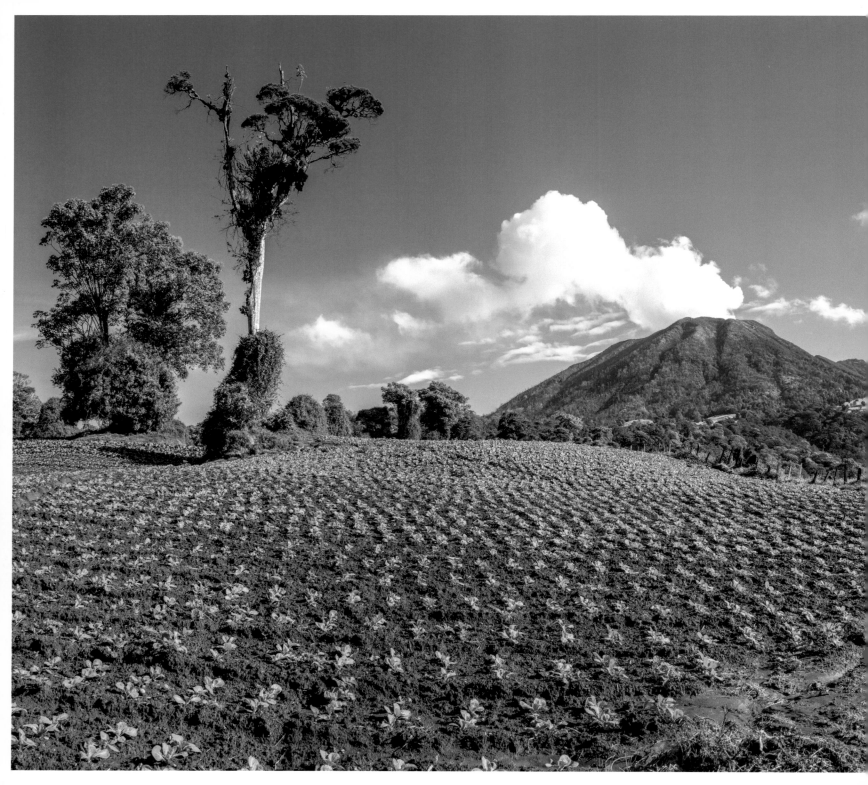

AT THE FOOT OF
THE VOLCANO

Even after years of urbanization, the cantons that surround Irazú—Oreamuno, Alvarado, and Cartago—are among the most important agricultural areas in the country. Though crops come from mostly small farms, this region produces more than 50% of the potatoes and onions grown in the country. In recent years, changes in rainfall patterns associated with climate change have lowered farm yields, thus endangering one of the economic pillars of the area.

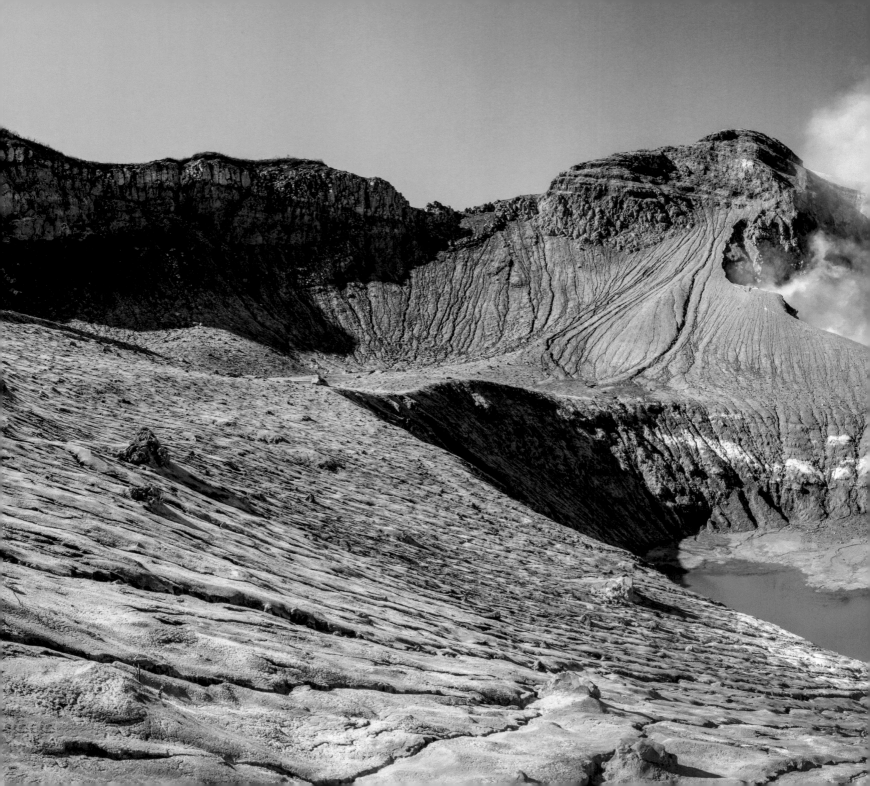

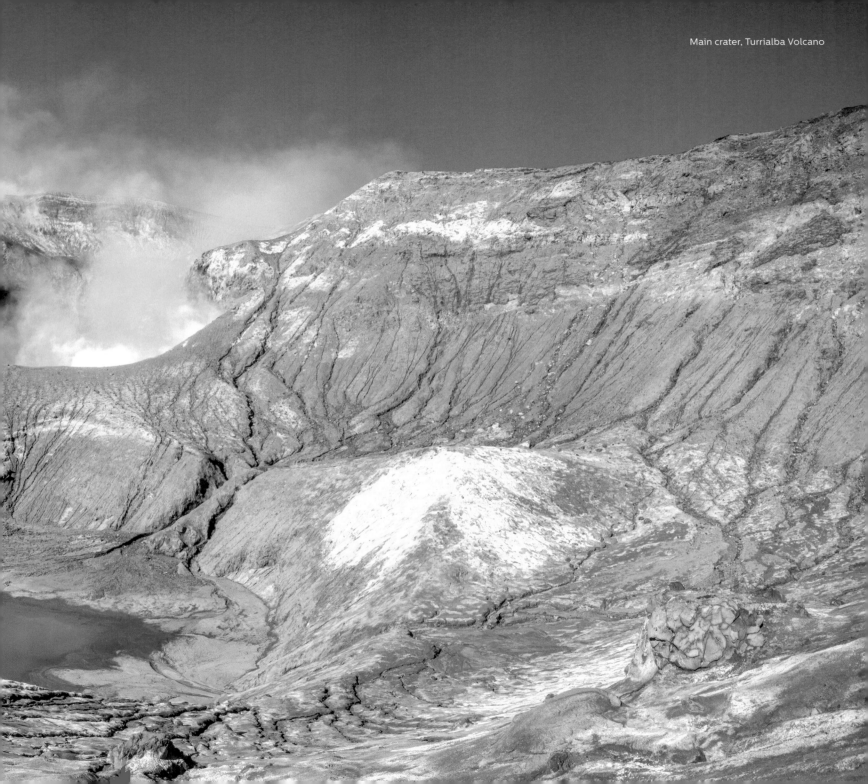
Main crater, Turrialba Volcano

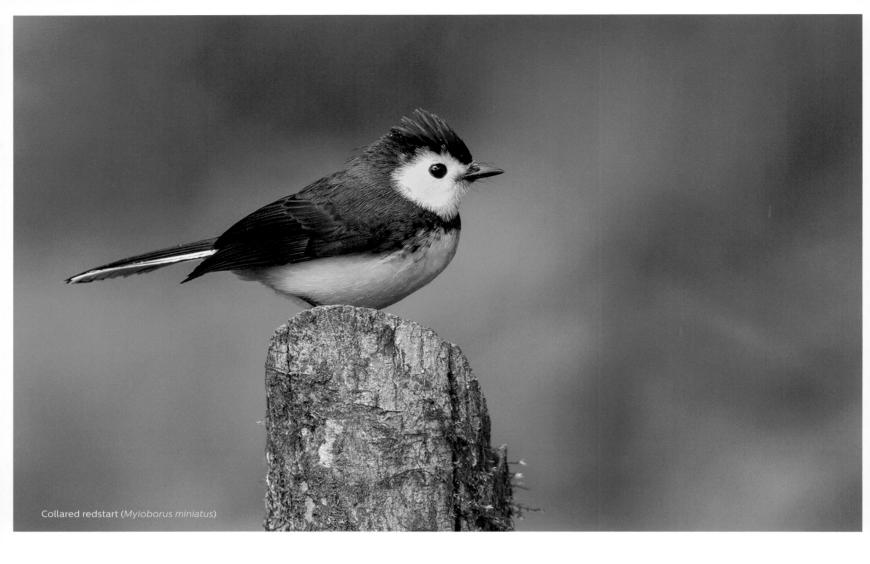

Collared redstart (*Myioborus miniatus*)

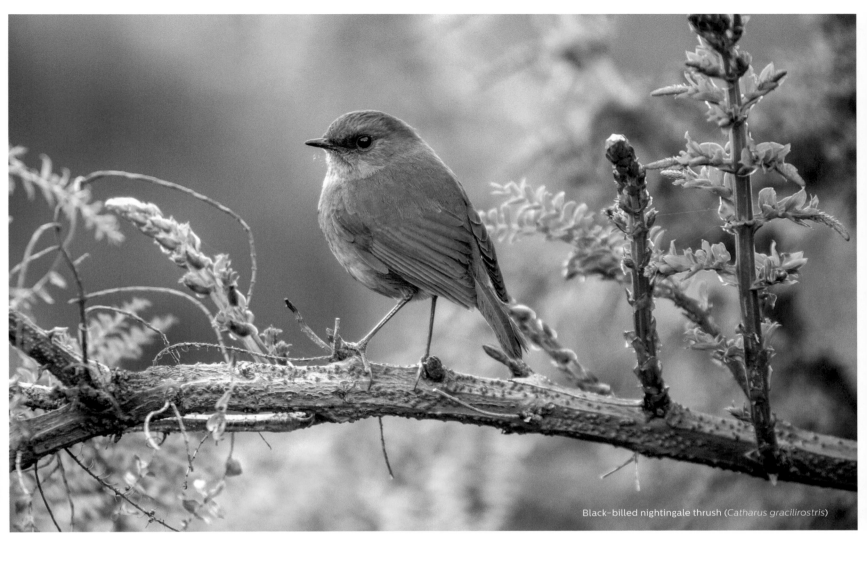

Black-billed nightingale thrush (*Catharus gracilirostris*)

On visits to Costa Rica, many birders shun the Central Valley and head straight to lowland rainforests, but it should be noted that there is great birding in this region too. The collared redstart and black-billed nightingale thrush, for example, are endemic to Costa Rica and western Panama.

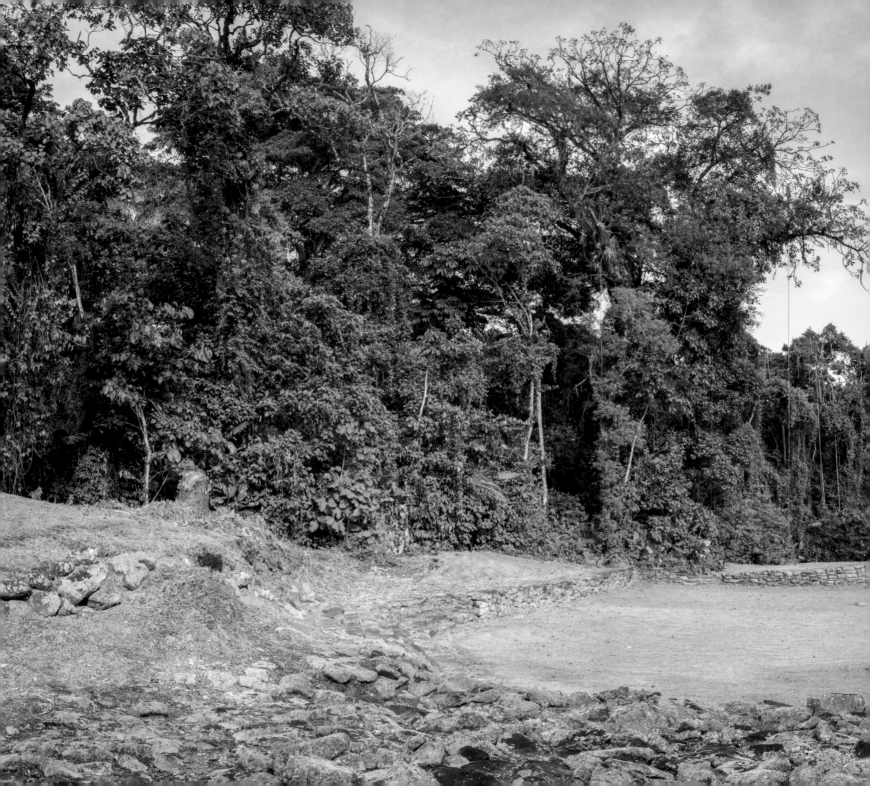

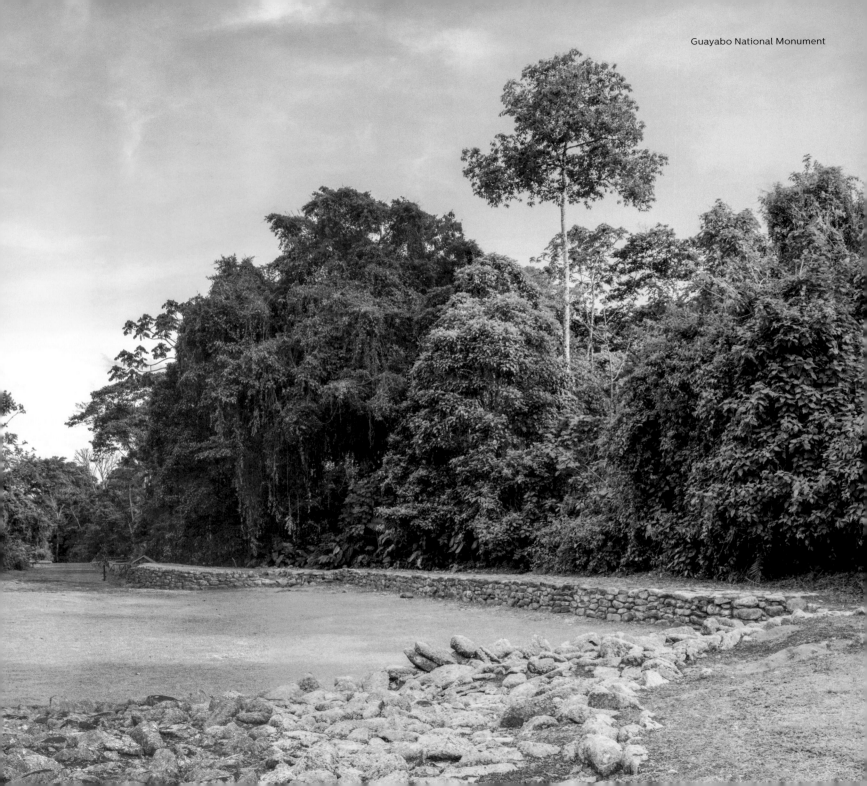

ORNITHOLOGY AND
ARCHEOLOGY

Mountain slopes and peaks give refuge to a great variety of birds. At high altitudes, many ecosystems are still relatively pristine compared to those at lower elevations. In these same mountains, one also encounters the ruins of Guayabo (see previous spread), once an indigenous settlement. For well over 2000 years (1000 BC to 1400 AD), it was an important center of political power and it continued to be inhabited until about 100 years before the arrival of the Spaniards. The archaeological plot comprises 573 acres (232 hectares), of which only a fraction has been excavated.

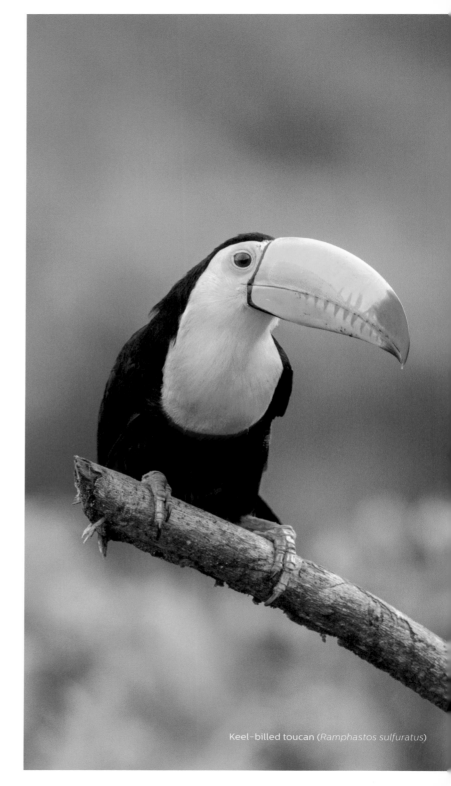

Keel-billed toucan (*Ramphastos sulfuratus*)

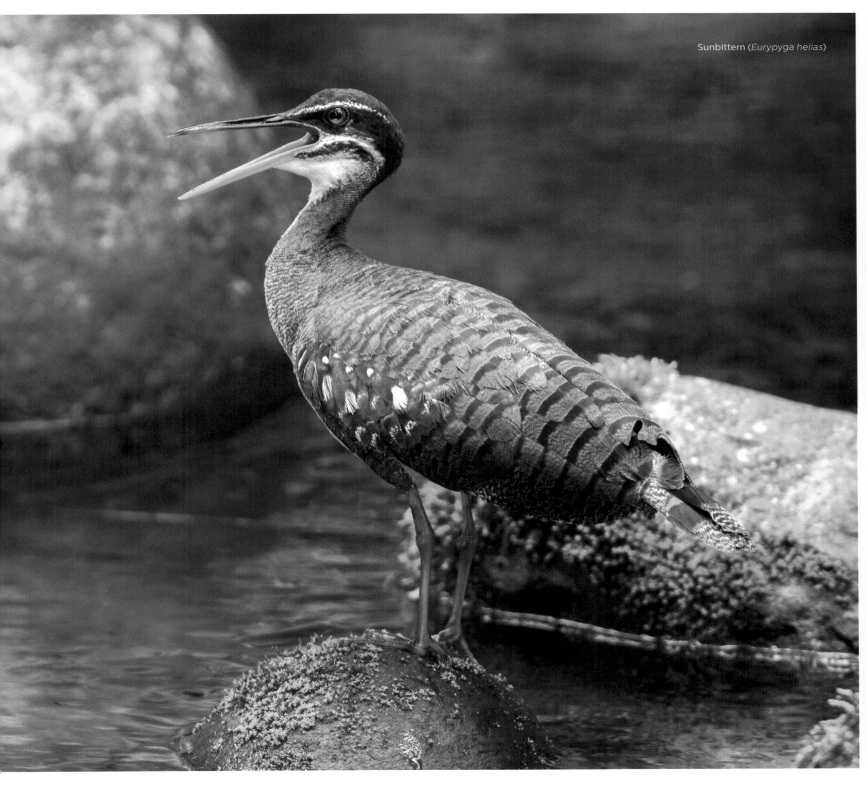

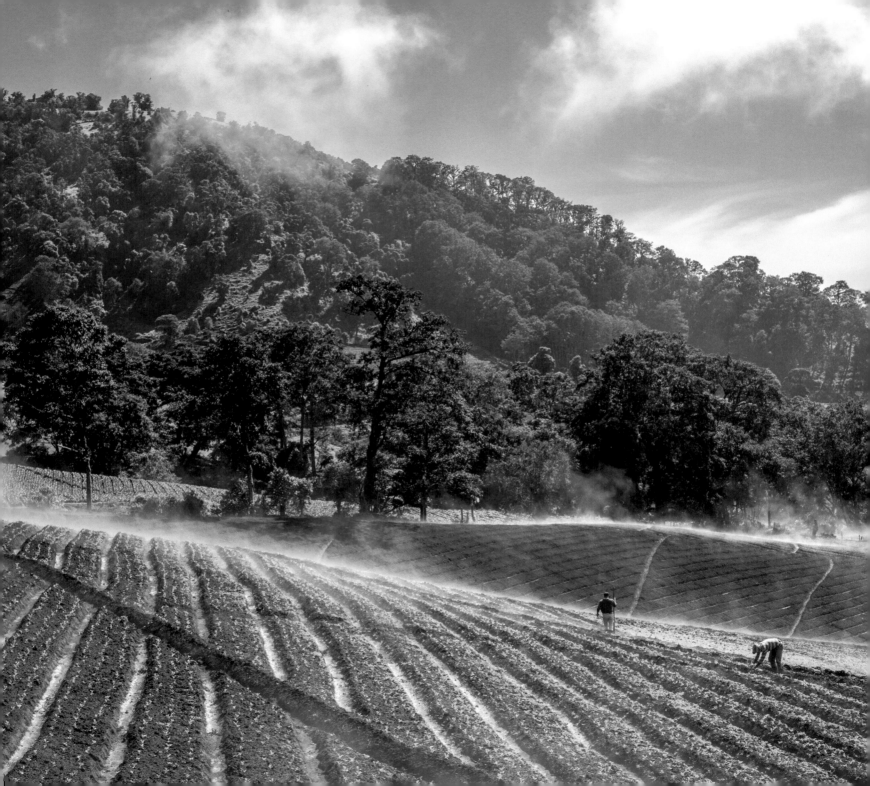

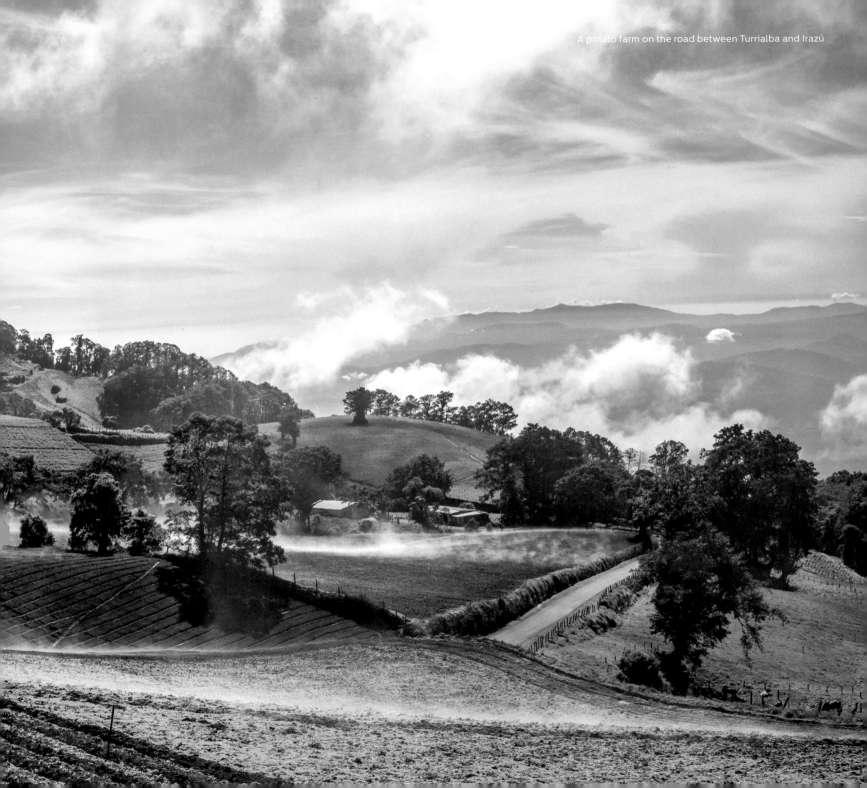

A potato farm on the road between Turrialba and Irazú

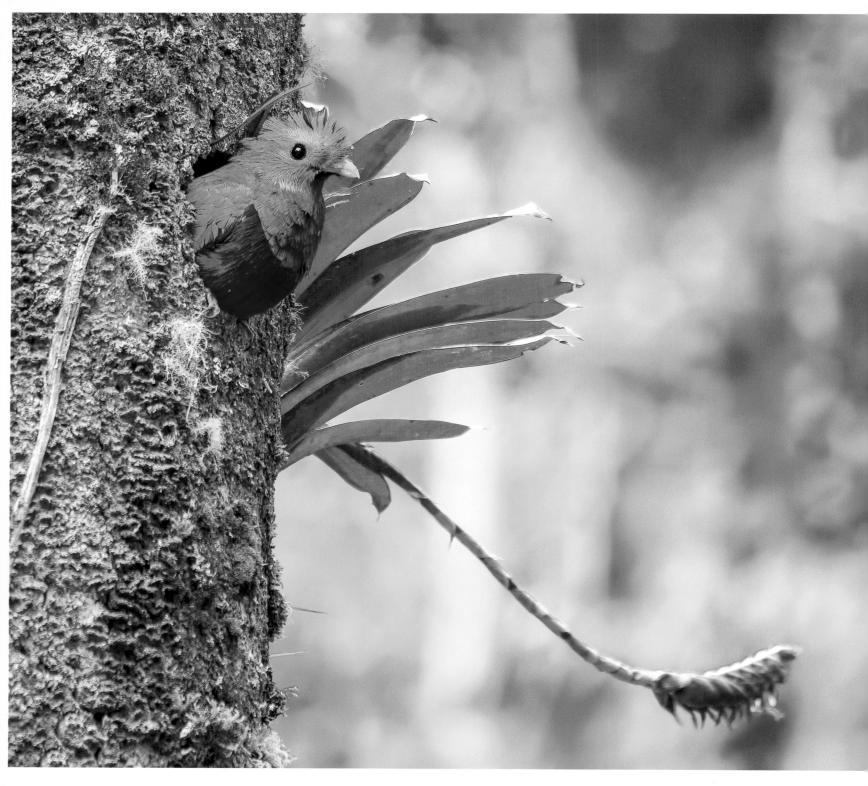

EMERALD BIRD

The resplendent quetzal (*Pharomachrus mocinno*), one of the most magnificent sights in the natural world, occurs in the Prusia Forest Reserve of Irazú Volcano National Park. Though they are less abundant here than in other parts of the country, this park is just a short drive from the capital city of San José.

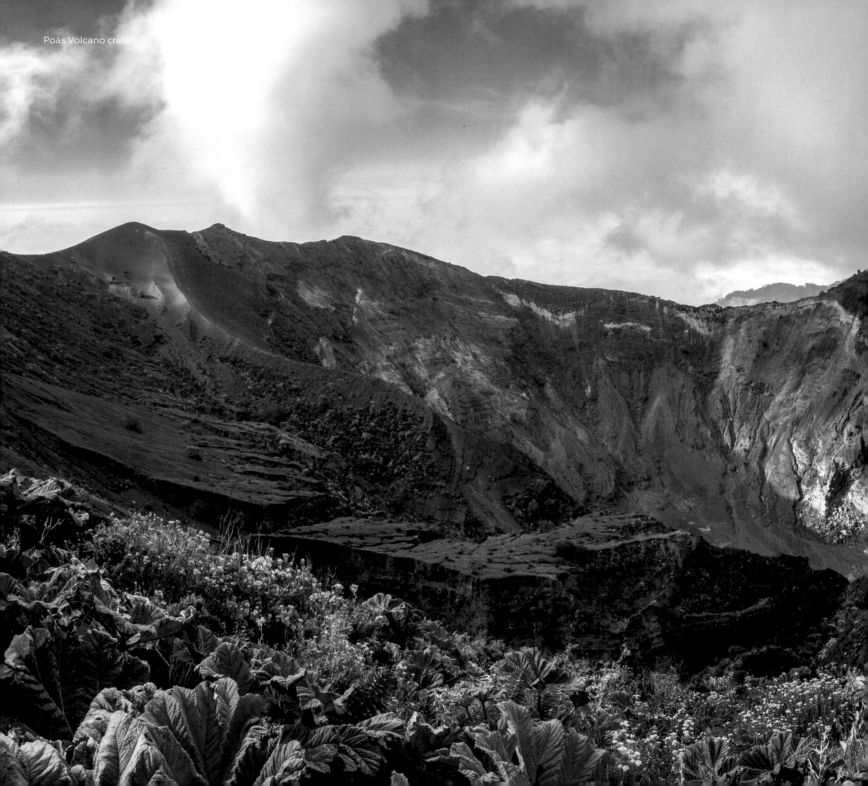

Poás Volcano crater

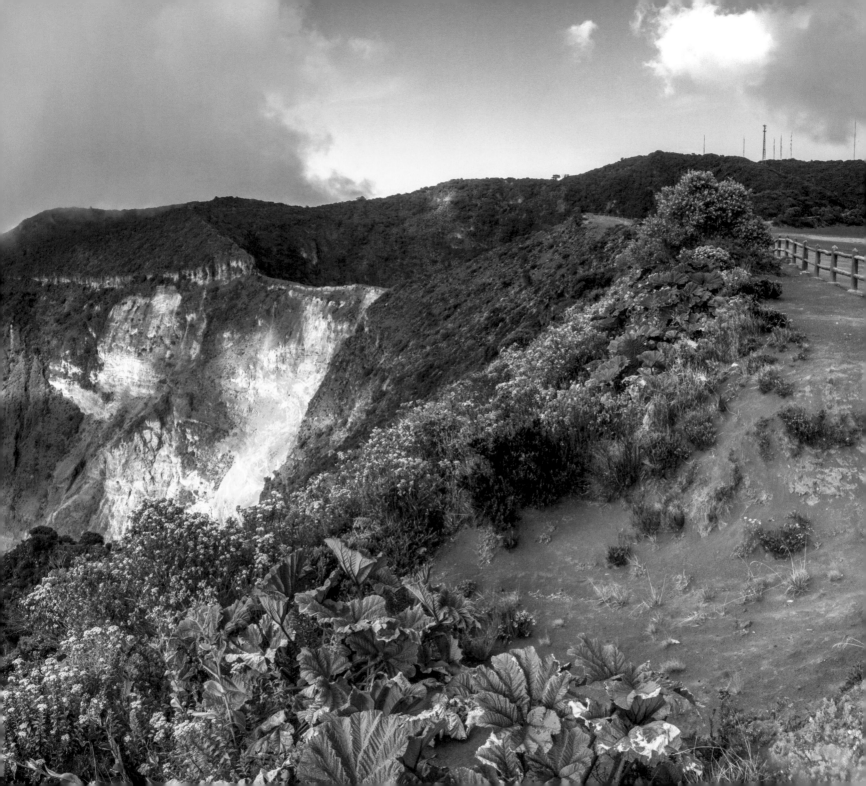

THE LIVING PAST

On the slopes of the volcanoes, the raising of cattle sustains entire communities. Along the zigzagging roads that lead up to the crater of Irazú, it is common to see old dairies, cattle herds, and even a farmer guiding an oxcart.

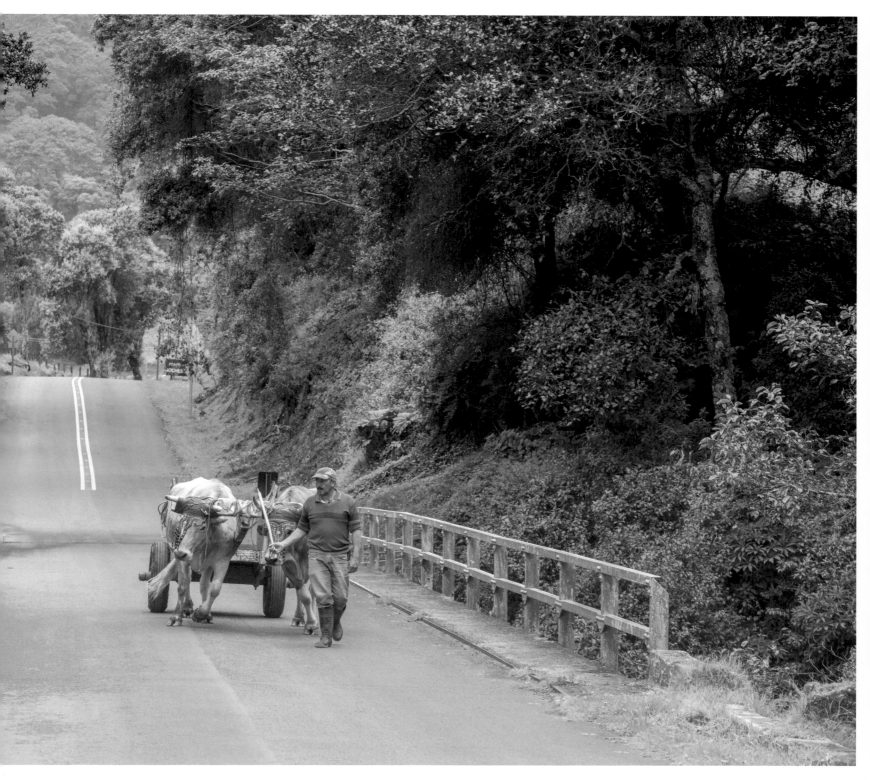

PARTY
CLOTHES

Some birds seem to seek attention in this mossy forest of pastel tones. The male orange-bellied trogon and the male elegant euphonia add splashes of color to the oak-forest ecosystem. The colorful plumages serve to attract females.

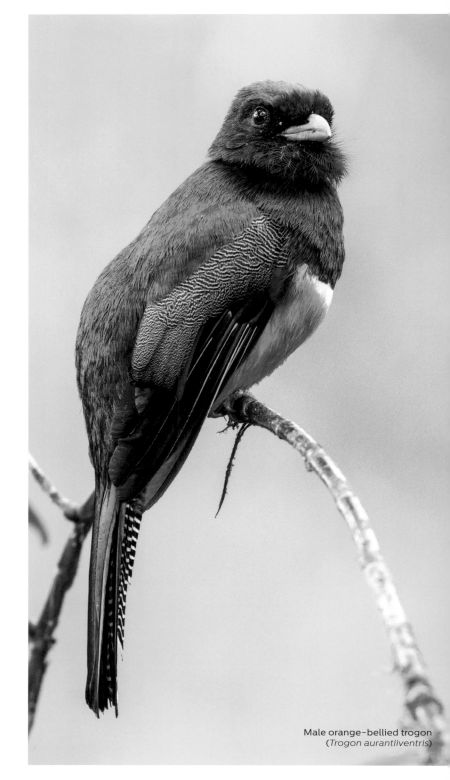

Male orange-bellied trogon
(*Trogon aurantiiventris*)

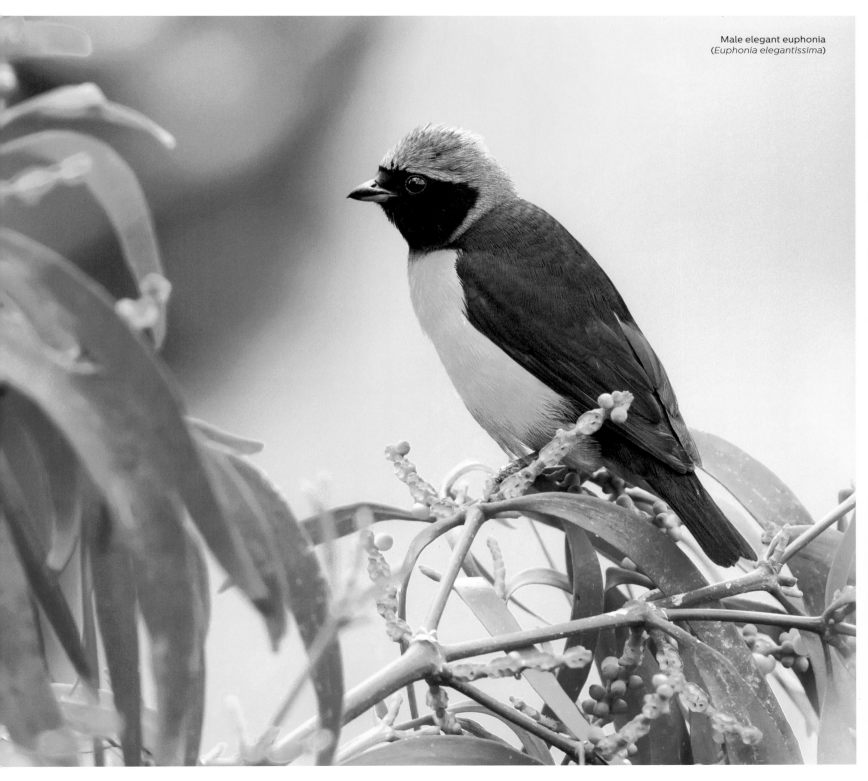

Male elegant euphonia
(*Euphonia elegantissima*)

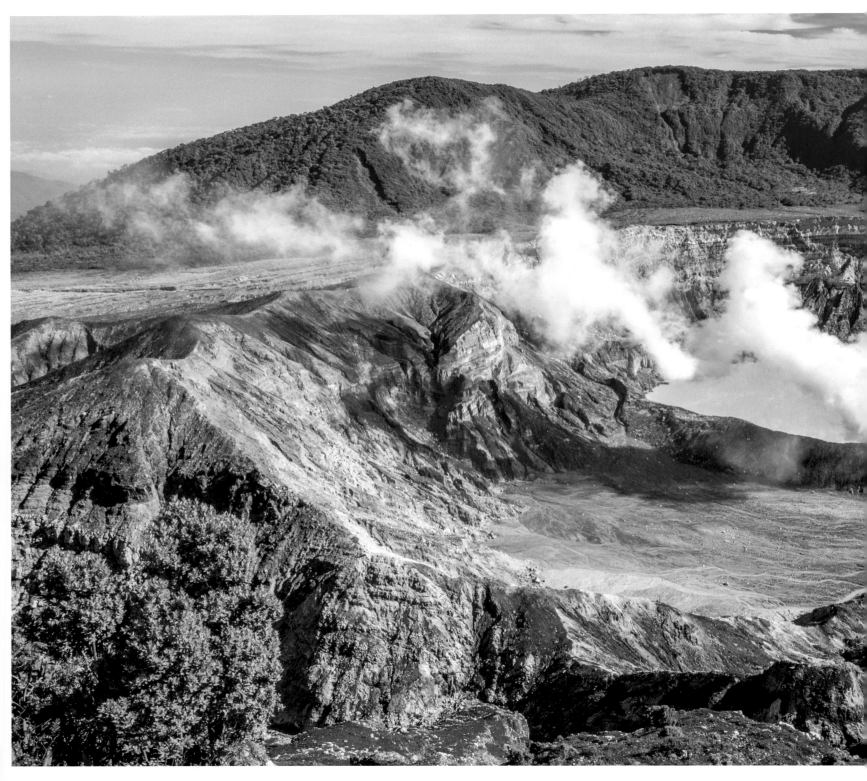

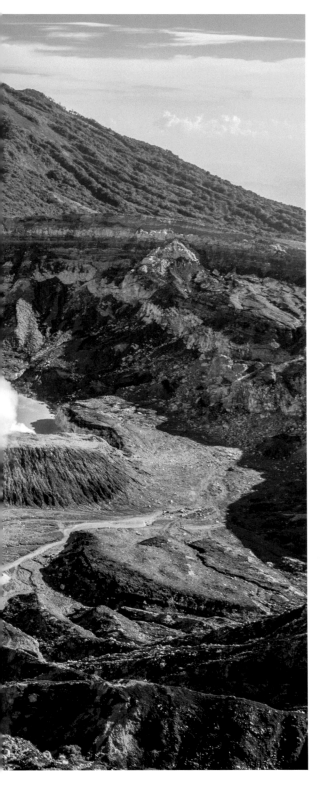

VOLCANIC
UNIVERSE

The main crater of Poás Volcano serves as a kind of diorama of geological time. In the foreground you can see a desiccated "beach," formed by deposits from lakes long gone and from volcanic eruptions. Behind it is a pale-blue lagoon of acidic, steaming hot waters 130-feet (40-m) deep. Behind the lagoon, on the lip of the crater, the rock strata record a history of eruptions.

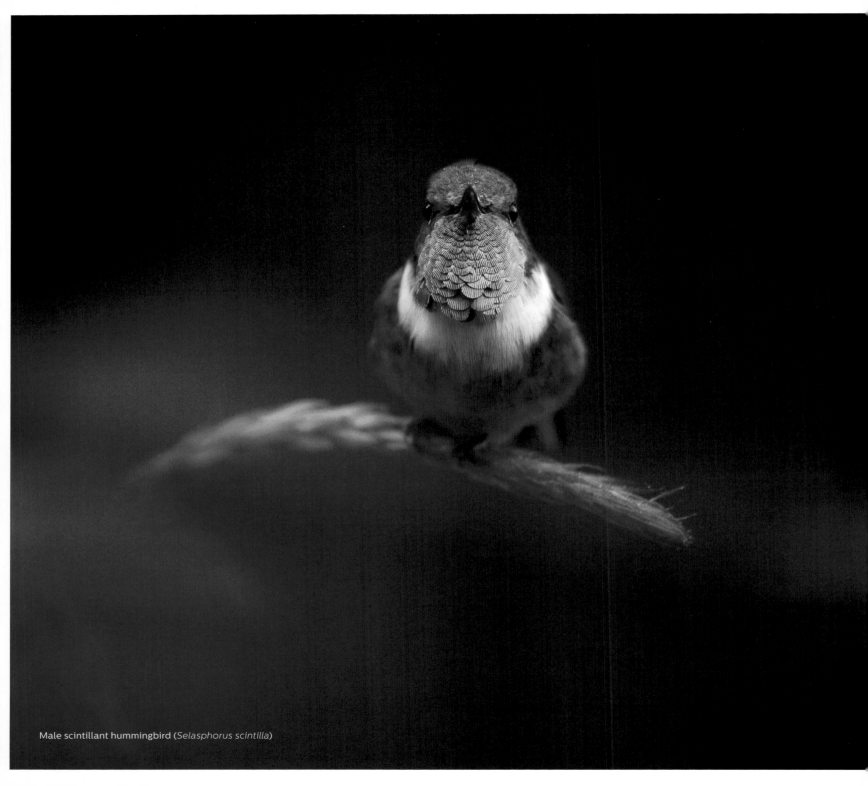

Male scintillant hummingbird (*Selasphorus scintilla*)

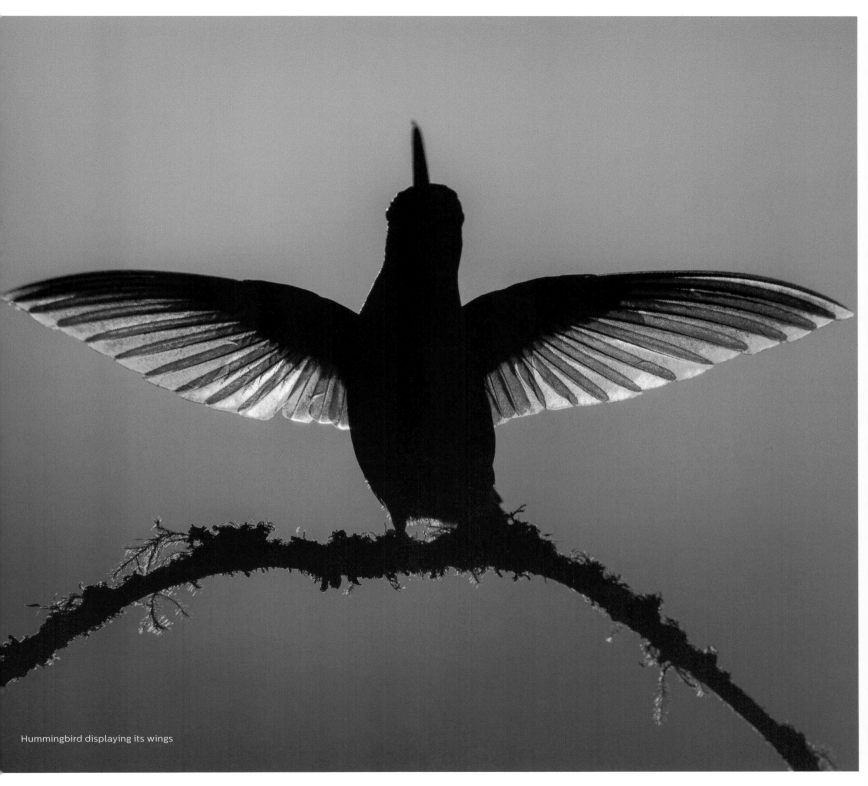

Hummingbird displaying its wings

FOREST
JEWELS

In the forests of Costa Rica, hikers who are too intent on seeing colorful birds or charismatic mammals may overlook the spectacular creatures at their feet.

Scarab beetle (Scarabaeidae)

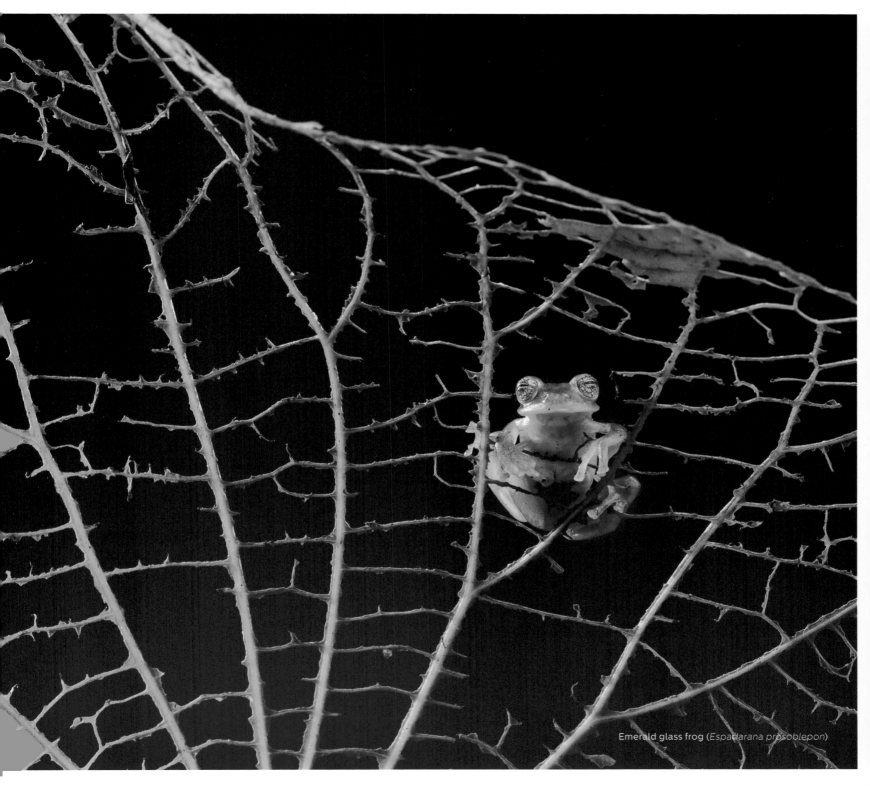

Emerald glass frog (*Espadarana prosoblepon*)

Although many people associate oaks with temperate climates, they also occur in the tropics. Costa Rica has approximately 10 species of oak trees, most of which are found at high elevations. These oak groves form their own ecosystem, with unique flora and fauna.

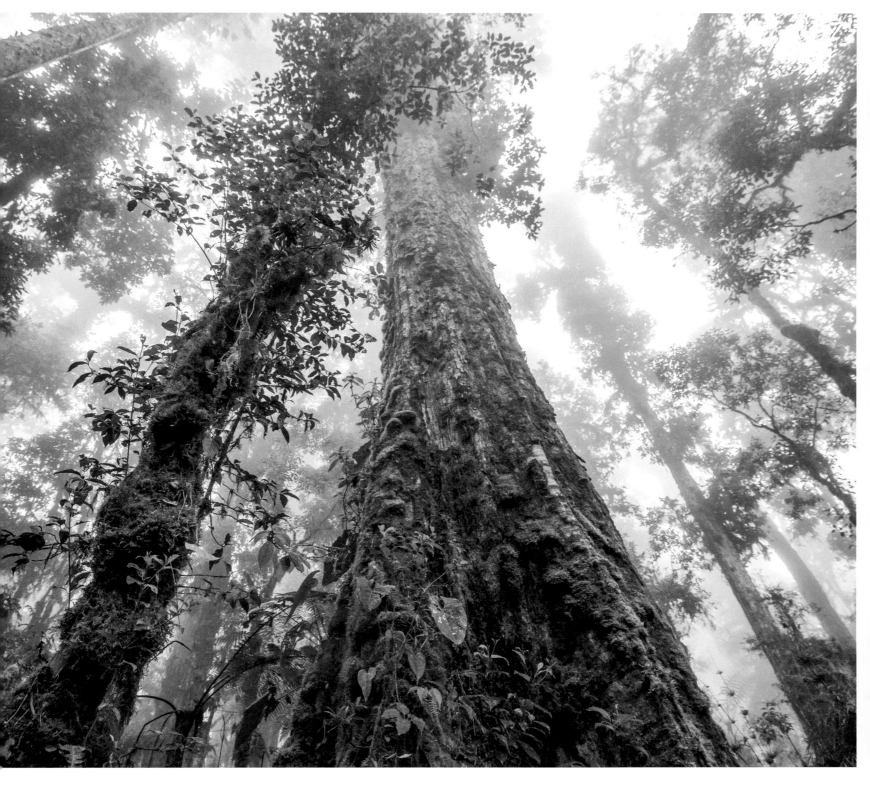

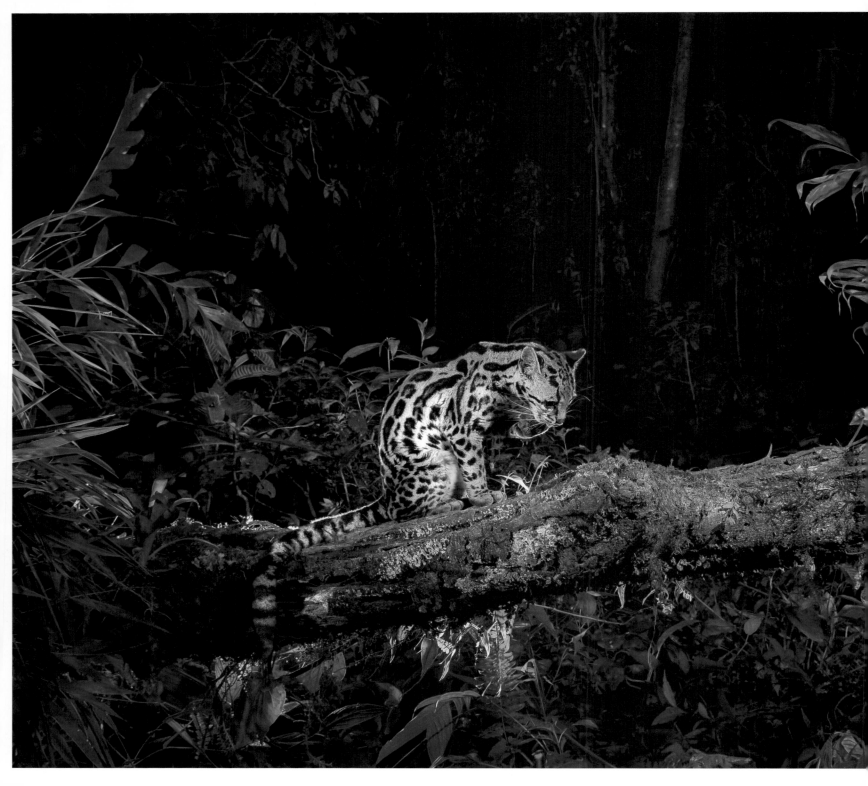

AN ARBOREAL CAT

As the forests surrounding the volcanoes were cut down, large cats such as the jaguar and the puma, which need massive tracks of land to survive, began to disappear. In smaller plots of forest, one cat that remains is the diminutive margay (*Leopardus wiedii*), an elusive nocturnal feline that spends most of its life in trees. When hunting—for monkeys or birds—the margay often hangs by its tail.

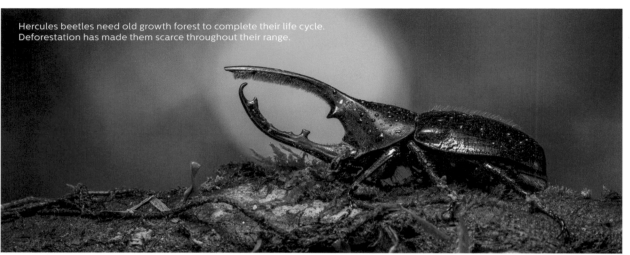

Hercules beetles need old growth forest to complete their life cycle. Deforestation has made them scarce throughout their range.

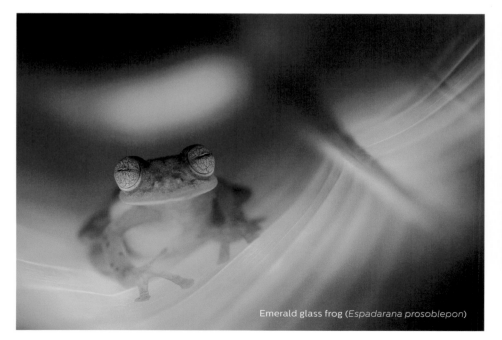

Emerald glass frog (*Espadarana prosoblepon*)

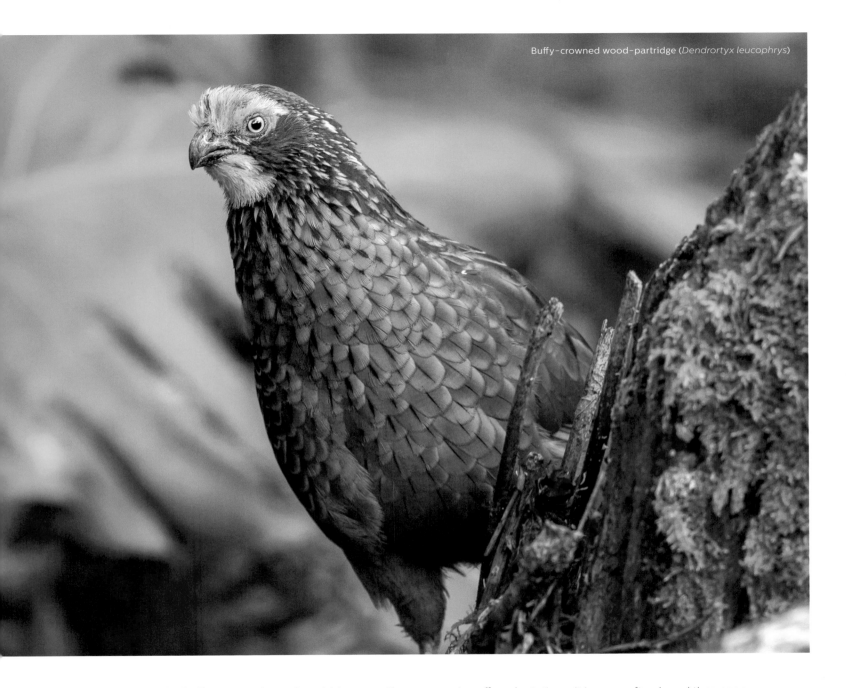

The buffy-crowned wood-partridge sometimes occurs in coffee plantations. It is more often heard than seen. Similarly, male glass frogs call throughout much of the year, which helps pinpoint their location.

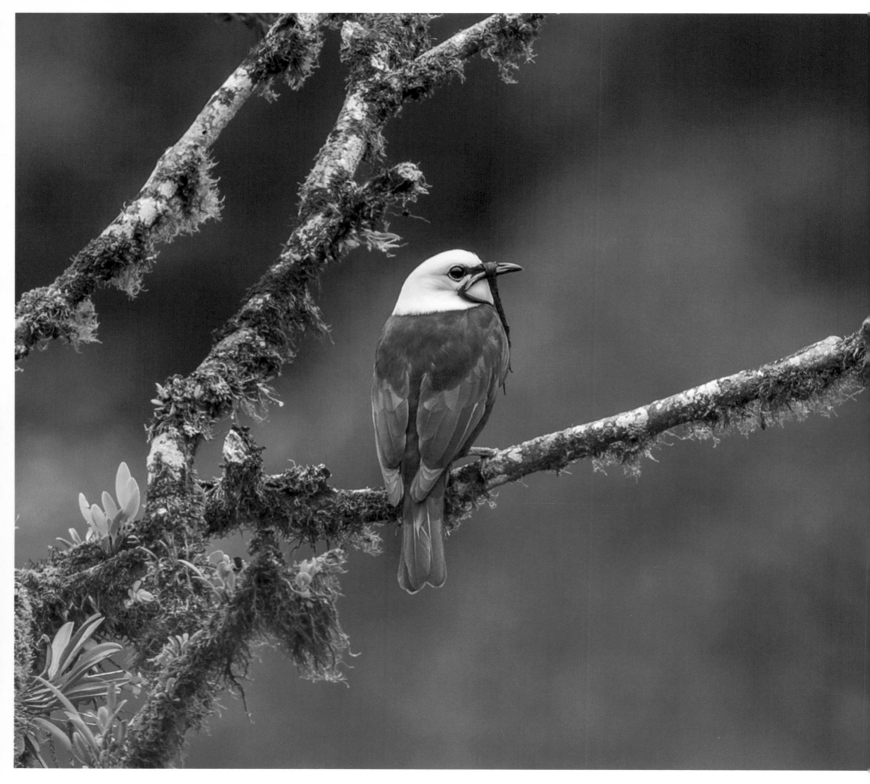

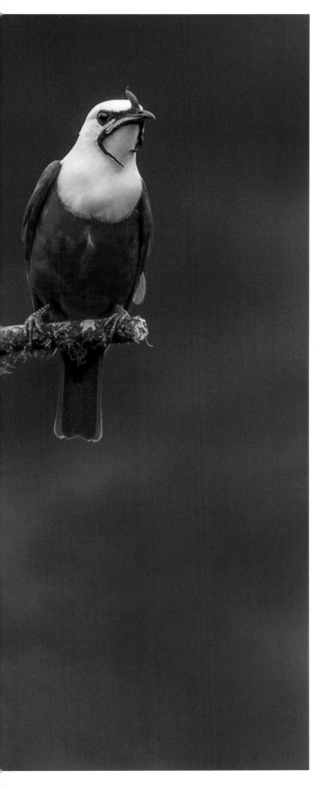

A BELL IN THE
FOREST

While other birds such as the quetzal may win the beauty contests, the distinct call made by the male bellbird (Procnias tricarunculatus) is a signature sound of middle and upper elevation forests. To attract females in mating season, he emits a call that can be heard up to 550 yards (500 m) away. Some research suggests that each male modifies his call throughout his life.

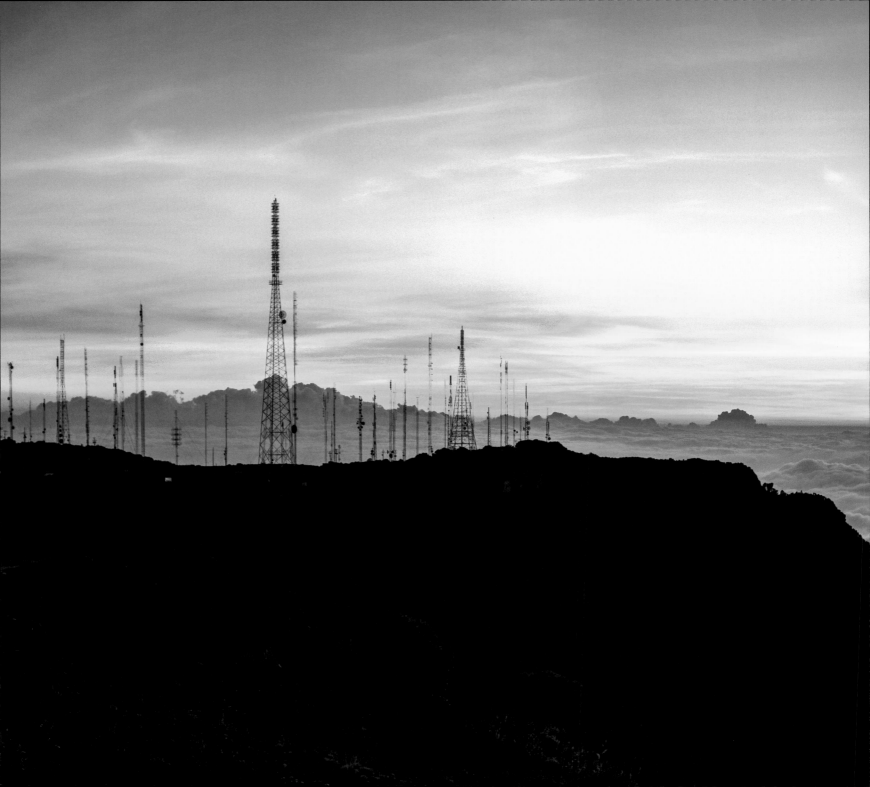

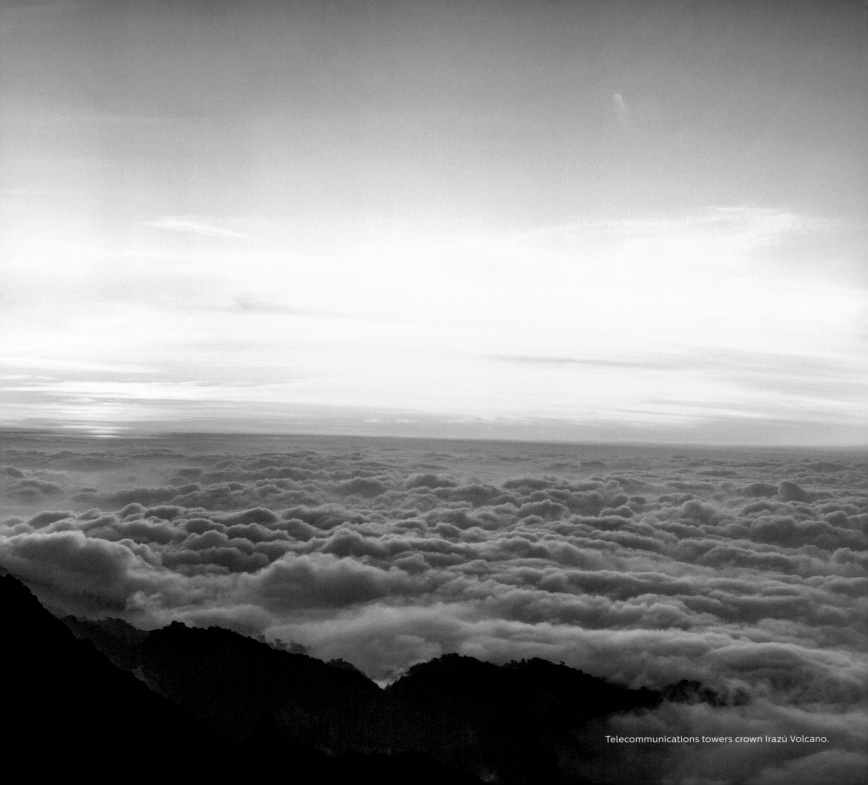

Telecommunications towers crown Irazú Volcano.

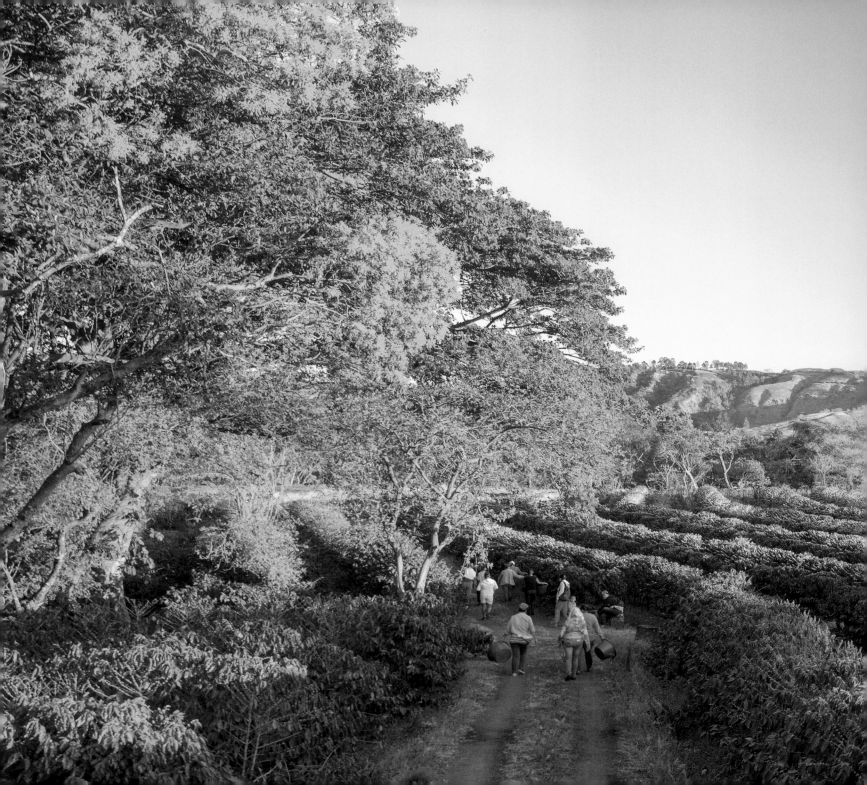

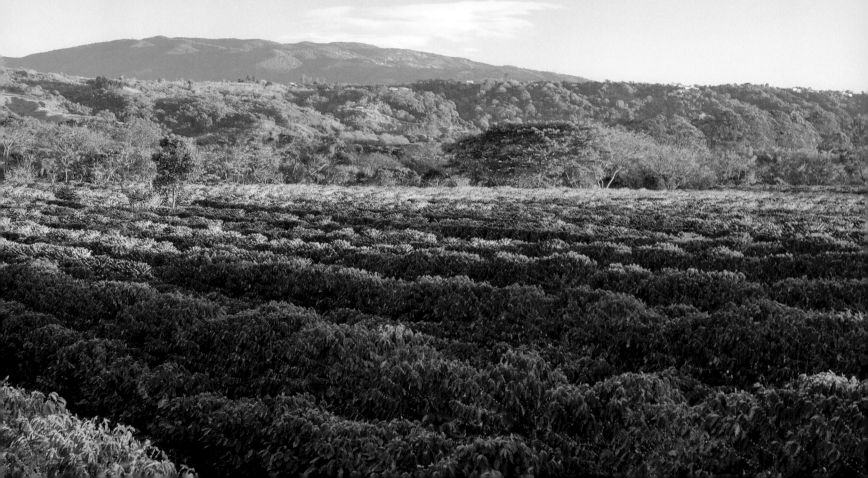

THE "GOLDEN BEAN"

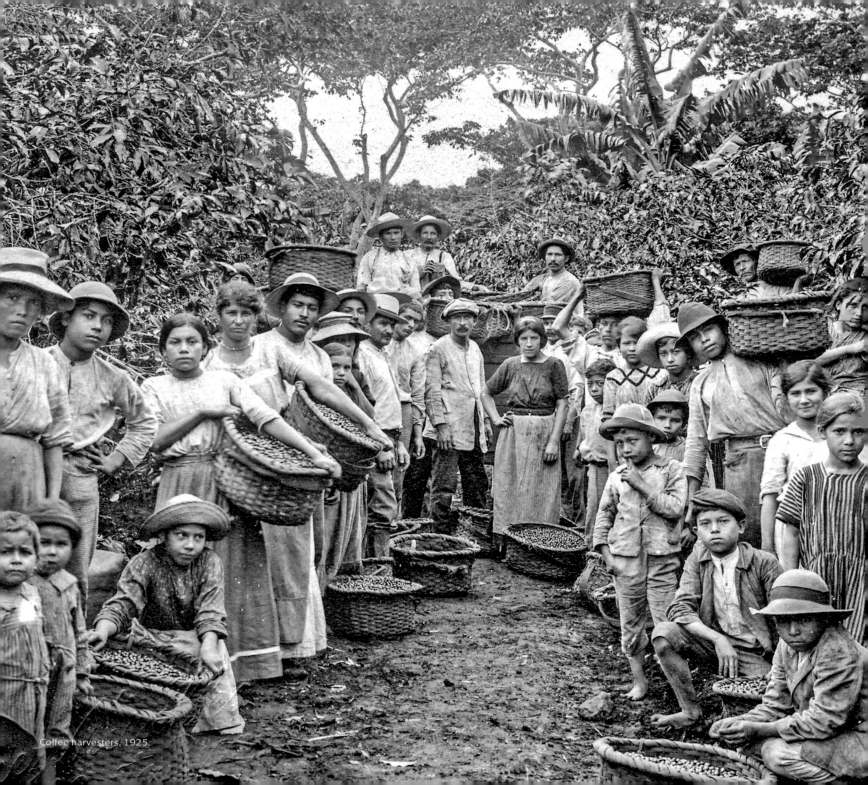

Coffee harvesters, 1925.

This story is set within a wide plateau bordered by mountains, the Central Valley, home to more than half of the population of Costa Rica and the focus of early efforts to colonize the country. In the early 1800s, Costa Rica was but a small corner of the Spanish empire, forgotten and with uninspiring economic prospects. The nation, then just a colonial province, lacked mineral deposits, cheap labor, and access to foreign markets. Its settlements—Cartago, the capital at the time, and the villages of San José, Alajuela, and Heredia—were mere collections of houses, too insignificant to be of interest to anyone living beyond the mountains that surrounded them.

But something arrived that would change everything. Some historians say that it was brought by Jesuits from Panama, others that is was carried as cargo on a merchant ship from the Caribbean islands, but what is certain is that a few decades before independence, in the late 1700s, something arrived that would change the fate of the country, the coffee plant.

Costa Rican history is the story of an addictive bean that emerged from the mountains of Ethiopia and Sudan to seduce the palate of the world. In Costa Rica, it did much more than change local tastes. It transformed the economy, society, infrastructure, and landscape of the country. For two centuries it was the most important export crop. It helped create a thriving middle class—a well-nigh unique case in Latin America—built the railroads, and set the school calendar. Thanks, in large part, to coffee, a poor and forgotten republic found a profitable niche in the global economy.

Volcanic activity in the Central Valley produced soils with low acidity, perfect for growing the most popular drink in the world. Most of the land has hospitable temperatures between 63 and 82 °F (17 and 28 °C), periodic and abundant rains, and an ideal elevation to grow coffee, between 2300 and 5250 feet (700 and 1,600 m). For almost two hundred years, nearly every person who lived in the valley had a direct or indirect relationship with coffee.

In the early 1800s, heads of state like Juan Mora Fernández and Braulio Carrillo realized coffee's potential and created policies to incentivize its production. The San José, Cartago, and Tres Ríos municipalities distributed plants to local residents, while the national government exempted coffee from the tithe tax and promised that whoever cultivated unused plots of land for a period of five years could claim that land as their own. Since then, there has been an unbroken link between the coffee sector and national politics; in the hall of former presidents of the Legislative Assembly, many of the presidents portrayed there were from the coffee elite.

At first, coffee growers had two jobs before them—growing the crop and establishing markets abroad. In 1843, Santiago Fernández Hidalgo, a farmer from Aserrí, set sail from Puntarenas under the auspices of an English captain with about 600 US tons (or roughly a half million kilograms) of coffee to try his luck for the first time in European countries. A few years later, two producers set up a stand in New York so that buyers from its stock market could try Costa Rican coffee beans. Slowly, the country built a reputation in the international market, which every year demanded more and more sacks from the Central Valley.

Nevertheless, Costa Rica continued to be largely rural and have little in the way of roads or other infrastructure. But the needs of the coffee industry would end up creating roads that all citizens could use. The first of note, finished in 1846, connected the Central Valley with the port of Puntarenas, whose ships carried coffee to North America and European capitals. The responsibility for maintaining this stone-paved road was assumed by the Compañía Itinerante, a group of coffee growers from San José and Cartago who were convinced of its importance for their industry. The construction of the railroads to the Pacific and Caribbean coasts, a few decades later, had a single focus—to facilitate the export of ever greater quantities of coffee beans (referred to as the *grano de oro* or golden bean).

Coffee production also influenced the layout of the streets that still today connect San José with the rest of the Central Valley. The roads to Aserrí, the Tres Ríos mountains, and the western valley towns of San Ramón and Poás were built for oxcarts carrying coffee. If 21st century Costa Rica inherited a system of narrow roads, it is because, until 1970, coffee dominated the life of the country.

Today, the very social structure of Costa Rica is in part the result of the history of coffee production. In other parts of the world, coffee growing was often dominated by a few large estates, which resulted in societies with deep inequalities. But in Costa Rica, there were also small coffee farms, whose owners were able to enter the middle class.

They owned their own land, were proud of the coffee they produced, and lived without being beholden to oligarchs. Even today, around 40% of Costa Rican production is sold through cooperatives, and 92% of coffee farmers in the country have farms of under 12 acres (5 hectares); together these represent nearly half of the cultivated land in the country.

Both large and small producers needed coffee pickers and, given the need for additional labor during the harvest season, the Costa Rican school year was established to allow a long vacation between December and February, when children joined in the coffee picking on the family farm. The payment of taxes also coincided with the coffee cycle, which gave a double boost to state coffers.

The National Theater, the architectural jewel of the country, was built in 1898 from these taxes. The first years of its

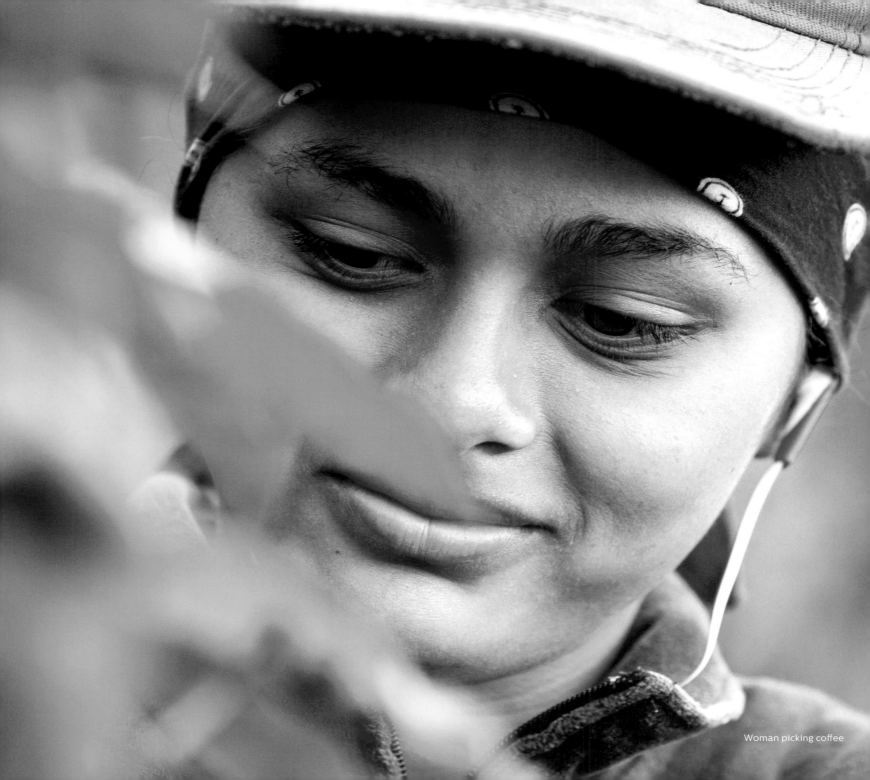
Woman picking coffee

construction were financed by a coffee export tax, created at a time of high international prices. Although the funds to finish the theater came from a tax on rice and beans, levied when the global markets for coffee were deflated, the legend of the theater paid for by coffee plantations lives on. If you visit the theater, which is a must, look up at the ceiling to see the iconic mural *Allegory of Coffee and Bananas*, one of the most famous artworks in the country; it appeared on the five-colon bill in 1968.

But the coffee bonanza came with a cost. On lands suitable for growing coffee, settlers cleared the jungle and replaced it with coffee plantations, stopping only at higher elevations not suitable for growing the bean.

Over the course of decades, land was cleared to make space for coffee. As one well-known naturalist commented bitterly, Costa Rica preferred to cultivate the most popular legal drug in the world than to protect its native forests. But now, both the coffee plantations and the remaining forests face the threats of climate change. Coffee plants "awaken" when it rains and ten days after the first rains, the first buds appear on coffee plantations in San Ramón, Aserrí, Santo Domingo, and Ujarrás. Abundant rainfall is needed for the plants to flower. But with climate change, the timing of the rains has become erratic; early showers can cause flowers to open before their time, and if the rains give way to a dry spell, the crop can be ruined.

Climate change has also lead to growing levels of humidity, which creates opportunities for the dispersal of coffee rust, a pest that can decimate entire coffee plantations. And, as temperatures rise, higher elevations that were once too cold for coffee cultivation have now become suitable lands for growing, with the result that high elevation forests are now being cleared. With increasing urgency, government officials and coffee growers are looking for new ways to produce coffee beans and protect the rural middle-class families that depend on the crop.

Time has brought another change, a welcome one. For decades, Costa Ricans willingly accepted the third-rate coffee that circulated in local markets. But in the 1990s, they began to learn

more about the excellent coffees the country produces, and cafés in San José started to offer quality brands. New generations became interested in so-called specialty coffees and with them came artisanal roasters, barista schools, and local tasters. Coffee went from being an export product to a passion among connoisseurs who discuss micro lots and exotic varieties.

In neighborhoods that were coffee plantations fifty years ago, such as Escalante and Dent, there are now cafes that offer exquisite coffees, establish close relationships with the farms that produce the coffees, and prepare them in a variety of ways. In these aromatic cafes, Costa Rican coffee is being rein-vented. What was a livelihood for the grandparents has become for the off-spring an art, a passion, and in many cases a new form of livelihood. San José is now largely devoid of coffee plants, and the first rains no longer prompt the white flowers of yesteryear. But as the rains come down, and new coffee enthusiasts seek shelter in newly opened coffee houses, the importance of this crop to daily life is as strong as ever.

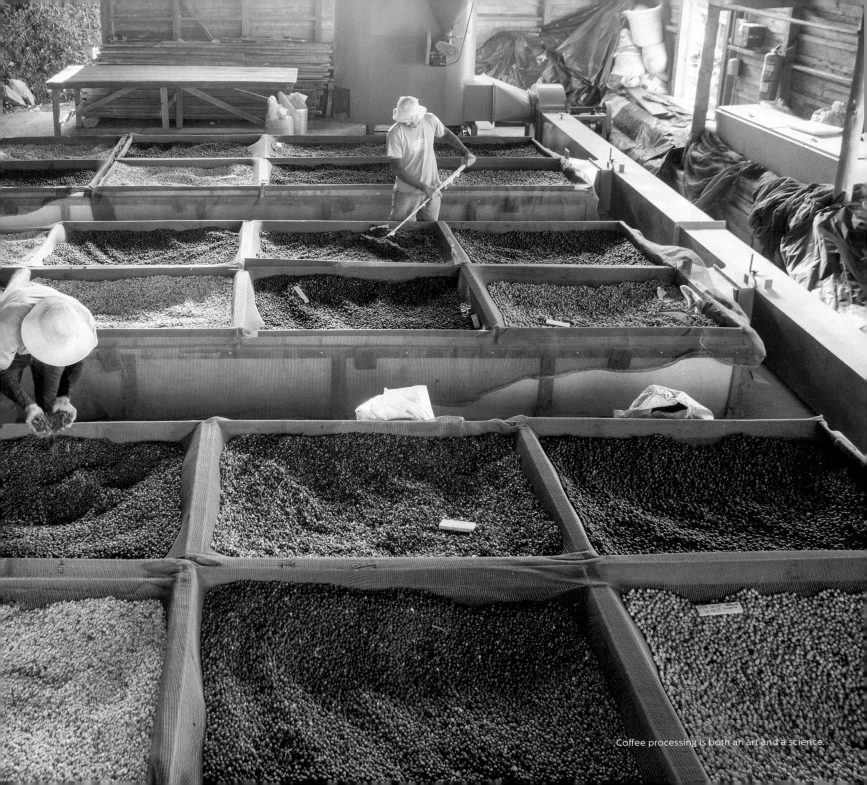

Coffee processing is both an art and a science.

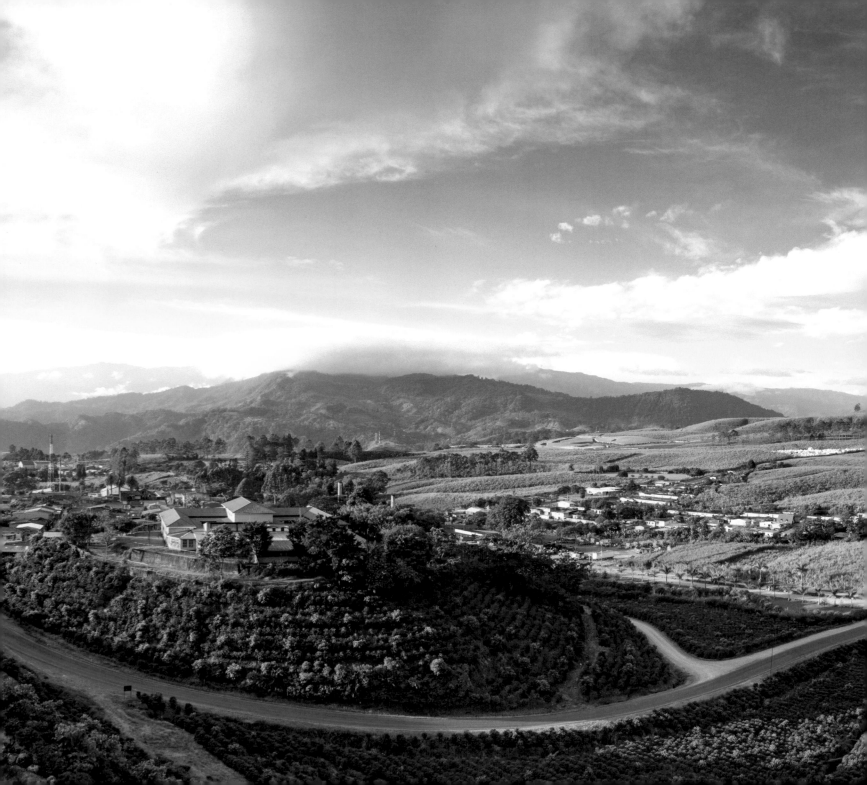

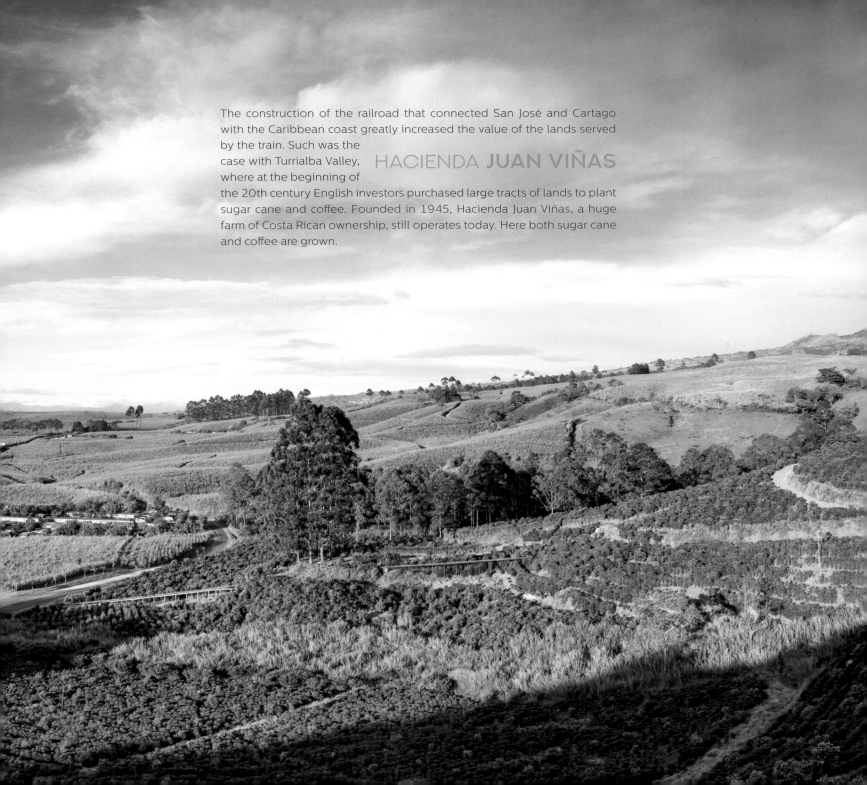

The construction of the railroad that connected San José and Cartago with the Caribbean coast greatly increased the value of the lands served by the train. Such was the case with Turrialba Valley, where at the beginning of the 20th century English investors purchased large tracts of lands to plant sugar cane and coffee. Founded in 1945, Hacienda Juan Viñas, a huge farm of Costa Rican ownership, still operates today. Here both sugar cane and coffee are grown.

HACIENDA **JUAN VIÑAS**

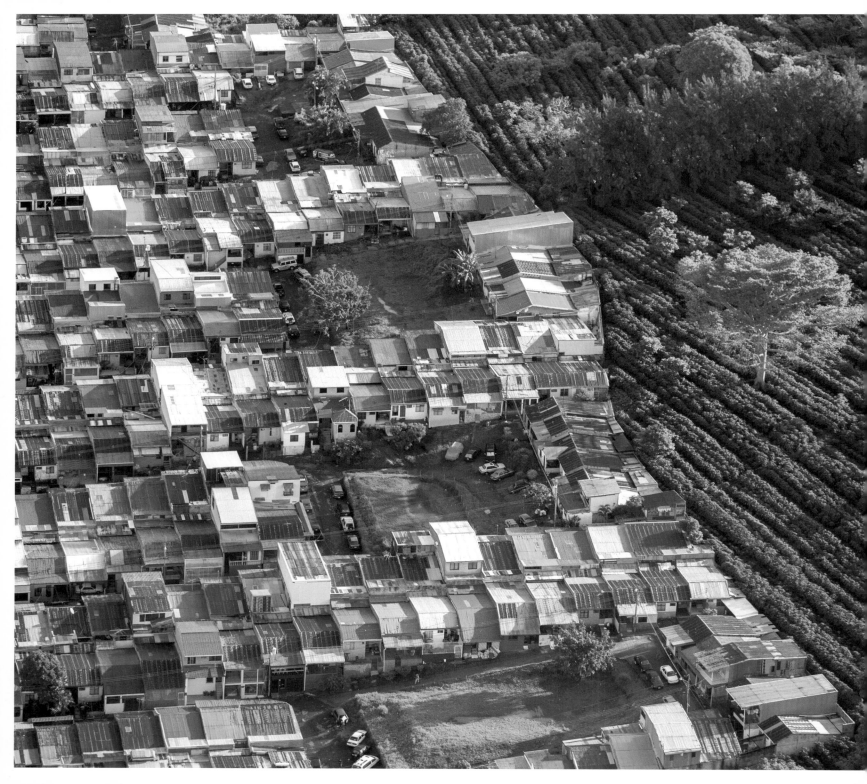

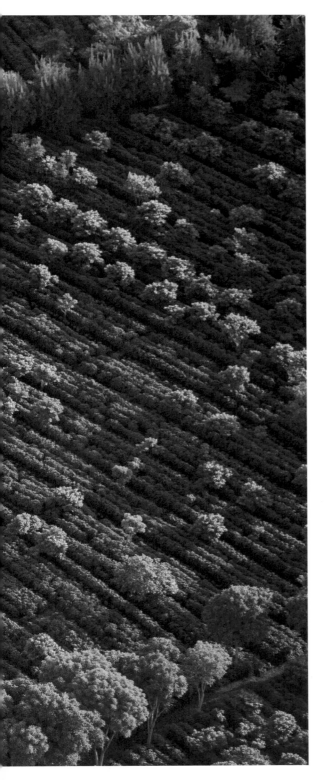

SIDE BY
SIDE

Coffee plantations have existed next to human dwellings for almost two centuries. As cities continue to encroach, coffee bushes are uprooted to make way for small houses with red roofs and narrow streets that relatively recently served for oxcarts.

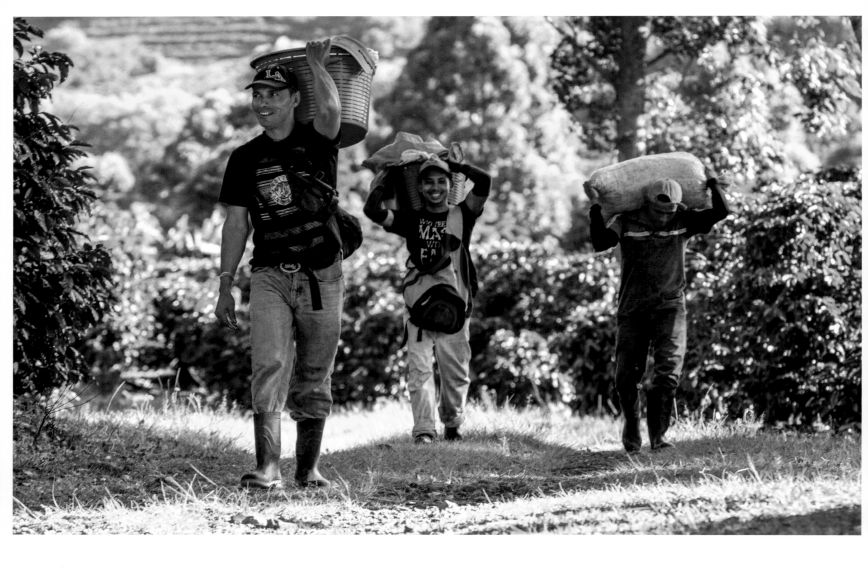

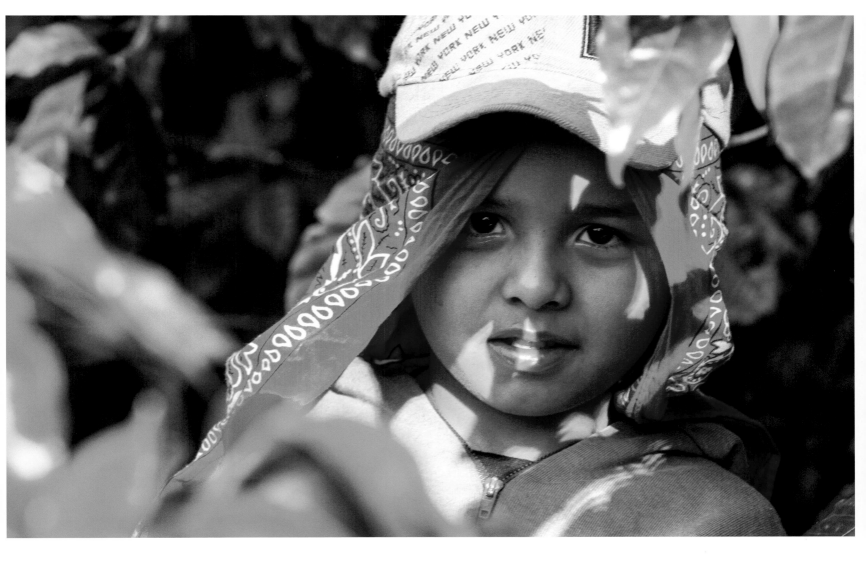

The Doka coffee farm, in Sabanilla de Alajuela, serves a dual purpose. During the day workers harvest the coffee, but Doka also receives tourists eager to learn about how coffee is produced. This is one of the largest coffee farms in the country and has the oldest coffee-processing plant in Costa Rica, Santa Eduviges.

THE FOREST
INTRUDES

Although coffee plantations replaced most of the tall forests in the Central Valley, they harbor life of their own. This is especially true of plantations that are enclosed by living fences (created by planting tree cuttings in the ground) and that have a variety of shade trees that protect riverbanks and aquifers; these serve as biological corridors for small and medium-sized birds and mammals. This volcano hummingbird (*Selasphorus flammula*), which is endemic to Costa Rica and western Panama, is nesting in a coffee bush in Llano Bonito de Tarrazú, home to some of the country's finest coffees.

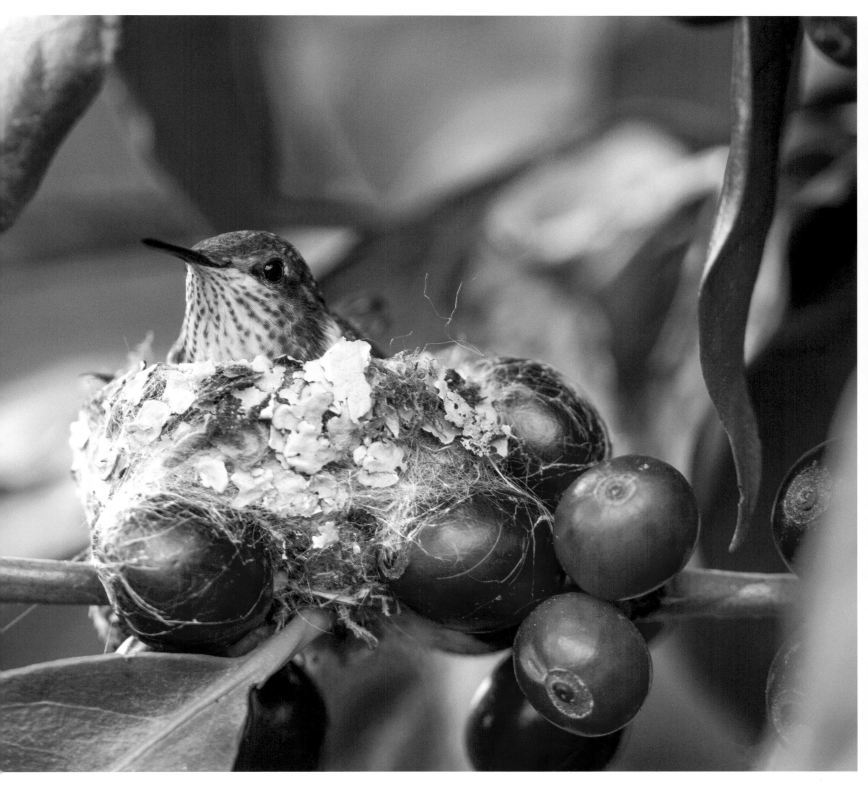

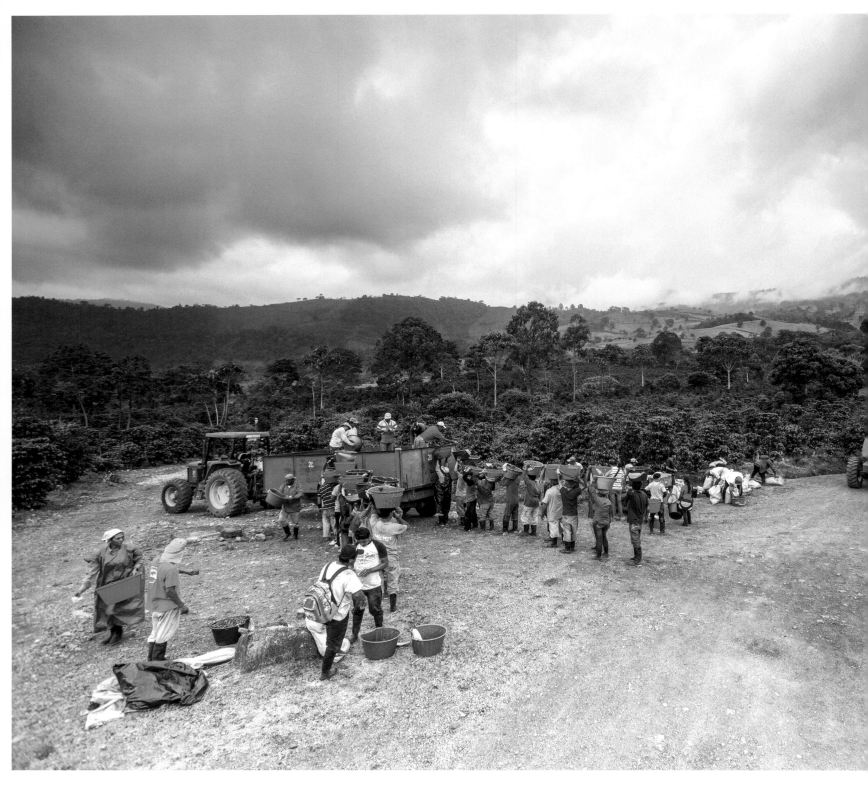

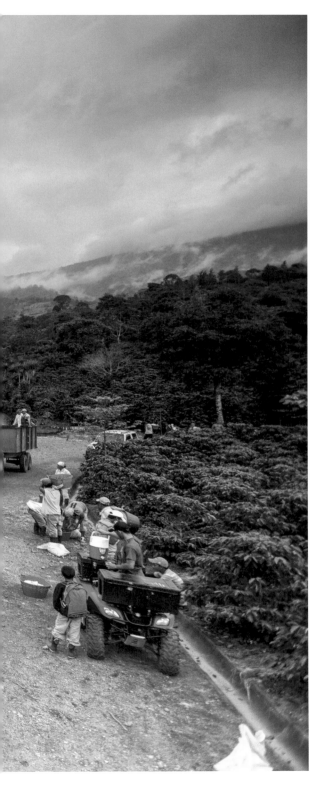

BEAN
COUNTERS

The cultivation of coffee in Costa Rica still relies on units of measure from the past. The work of each harvester is calculated in *cajuelas*, or about 26 pounds (12 kg). At the end of each day, the coffee that has been picked is measured in terms of *cajuelas*, half *cajuelas*, or quarter *cajuelas*. Workers are paid only for what they pick.

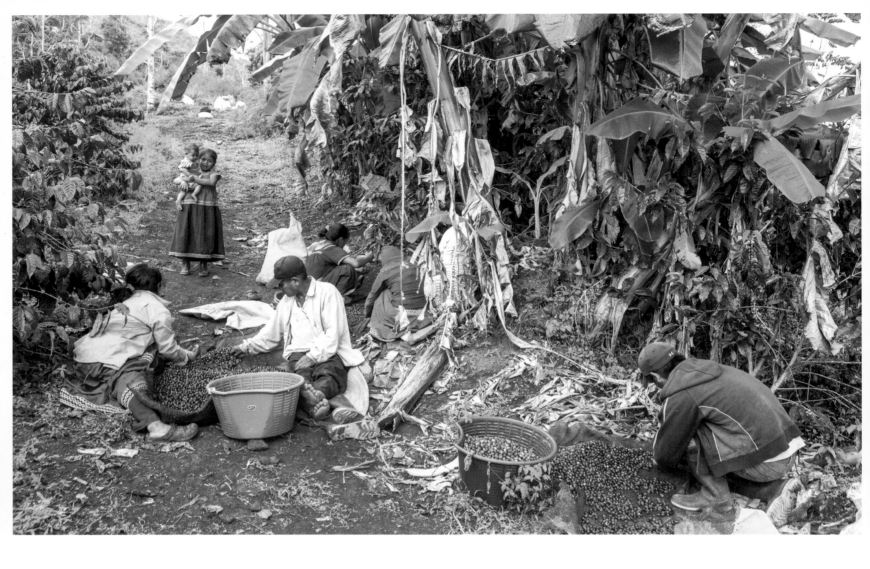

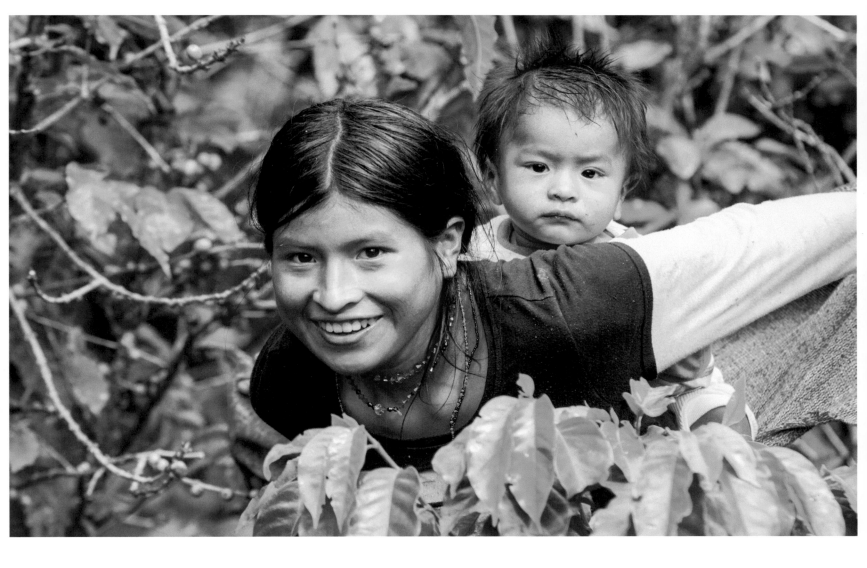

Since the early 1990s, the Gnäbe indigenous community have played a leading role in the harvesting of coffee in southern Costa Rica. On any given year, 10,000 to 15,000 members of this community travel from Panama for the harvest season. They usually spend several months on a given farm.

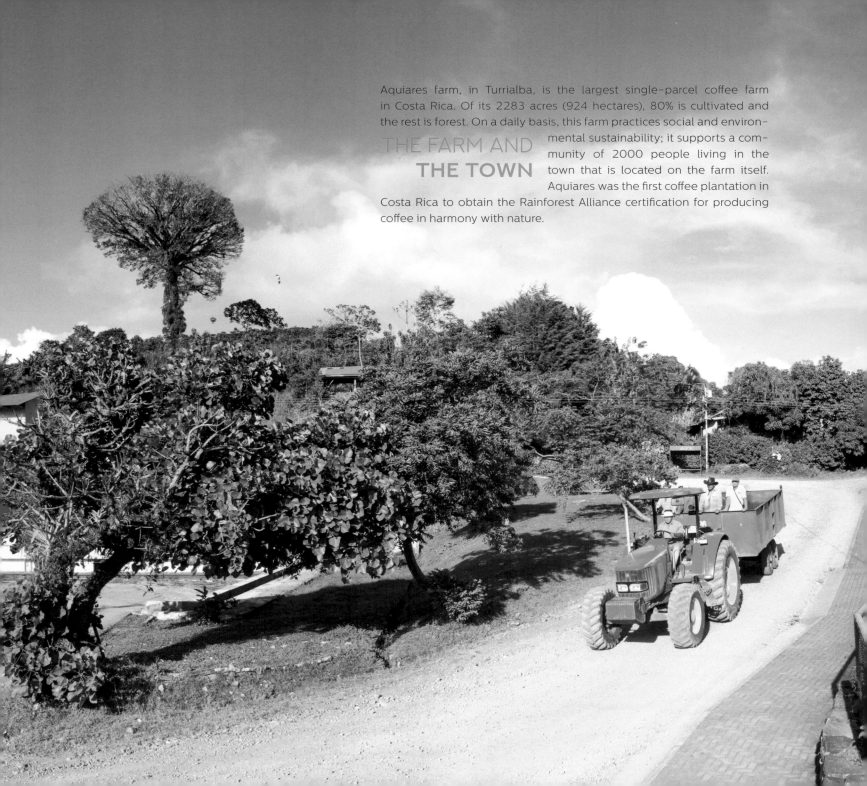

Aquiares farm, in Turrialba, is the largest single-parcel coffee farm in Costa Rica. Of its 2283 acres (924 hectares), 80% is cultivated and the rest is forest. On a daily basis, this farm practices social and environmental sustainability; it supports a community of 2000 people living in the town that is located on the farm itself. Aquiares was the first coffee plantation in Costa Rica to obtain the Rainforest Alliance certification for producing coffee in harmony with nature.

THE FARM AND
THE TOWN

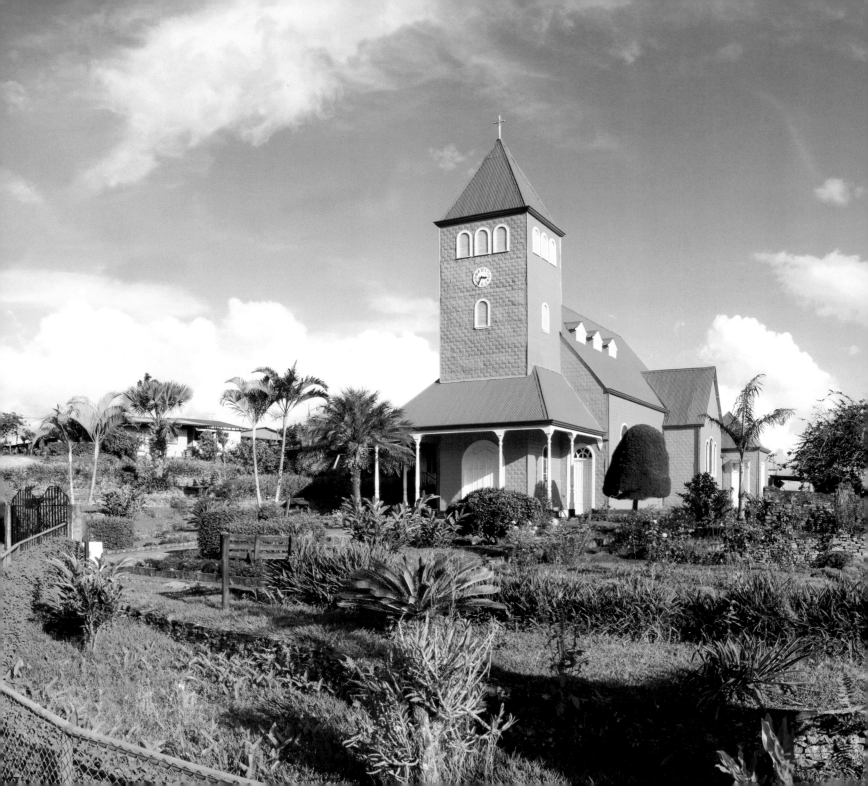

Some of the best coffee in the country comes from San Marcos de Tarrazú. Each farmer delivers his harvest to the local coffee-processing plant, and it is these plants that historically often made more money than the farmer. Although this model still dominates, a new trend started in 1998. On small plots of land, the farmer creates his own micro-processing plant and sells directly to the final consumer abroad.

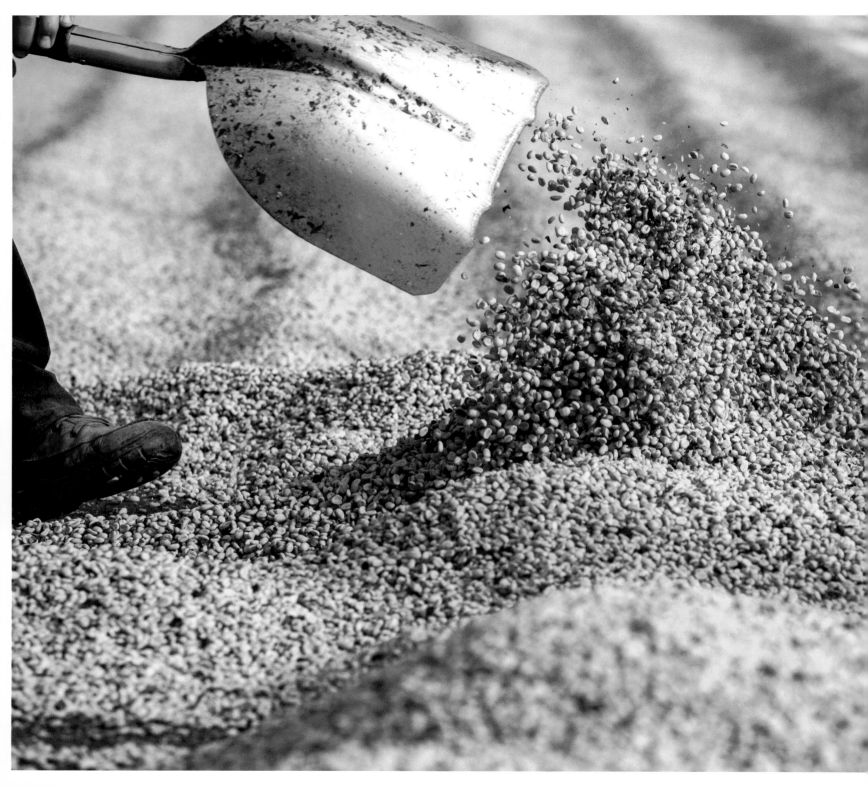

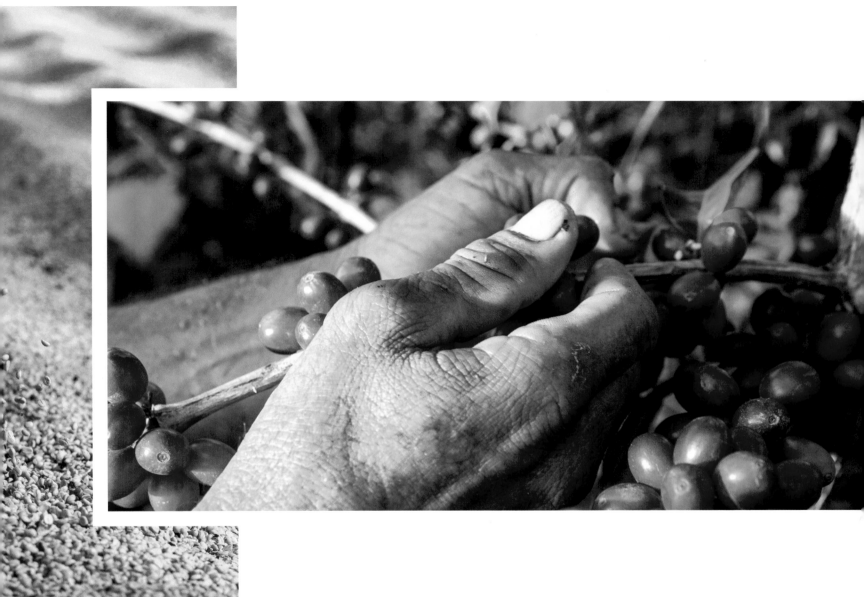

All Costa Rican coffee is harvested by hand, bean by bean. A skilled coffee "picker" knows to only choose ripe fruits to ensure the quality of each cup. From harvesting to the drying process, Costa Rican coffee relies on expertise at every phase.

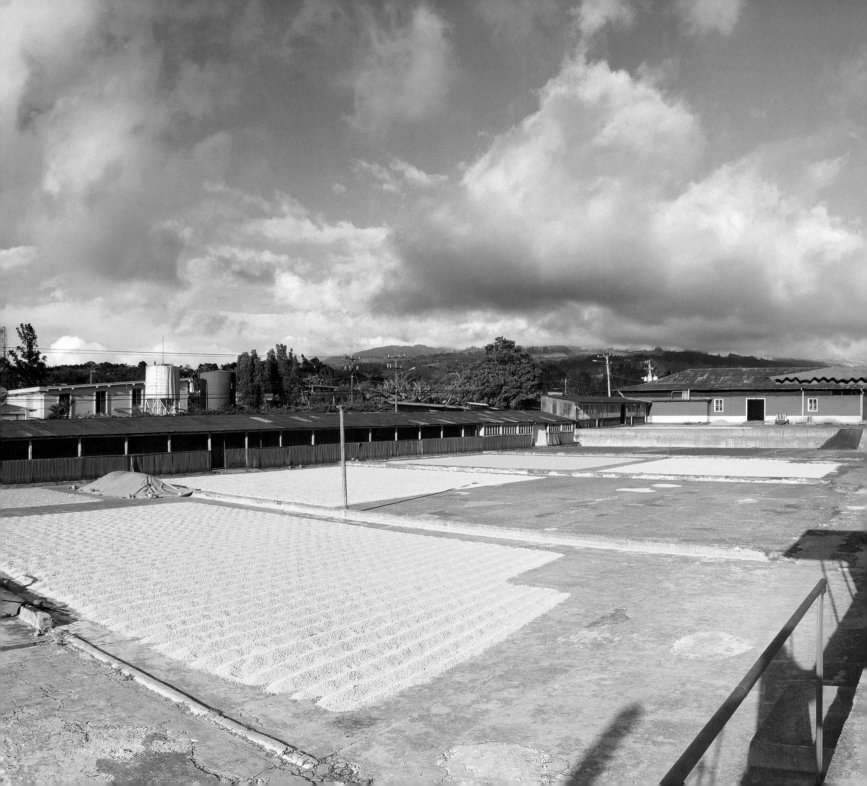

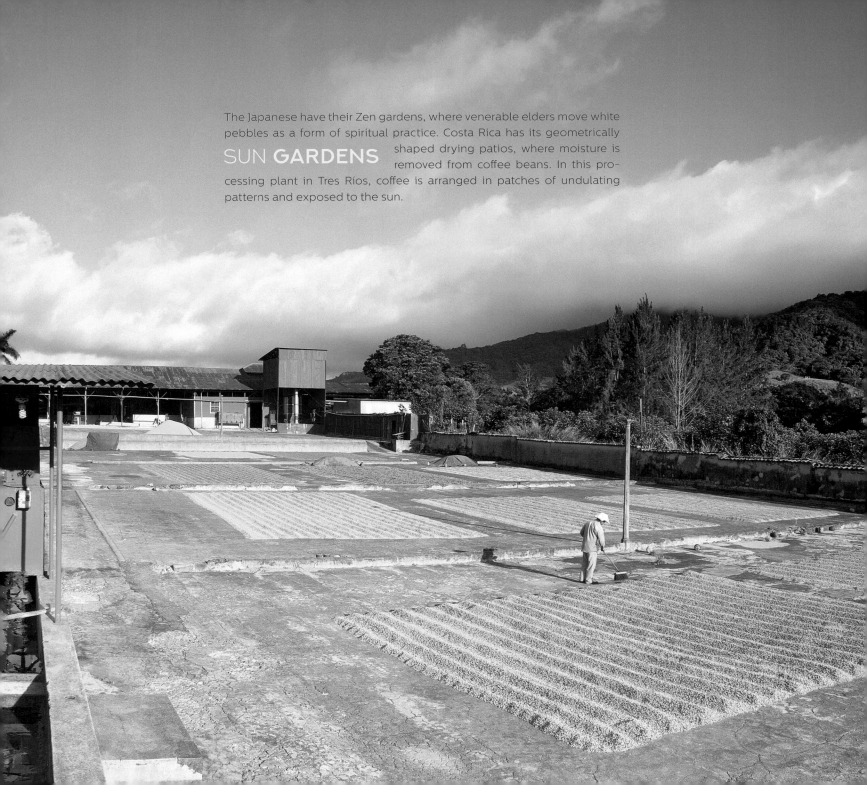

The Japanese have their Zen gardens, where venerable elders move white pebbles as a form of spiritual practice. Costa Rica has its geometrically shaped drying patios, where moisture is removed from coffee beans. In this processing plant in Tres Ríos, coffee is arranged in patches of undulating patterns and exposed to the sun.

SUN GARDENS

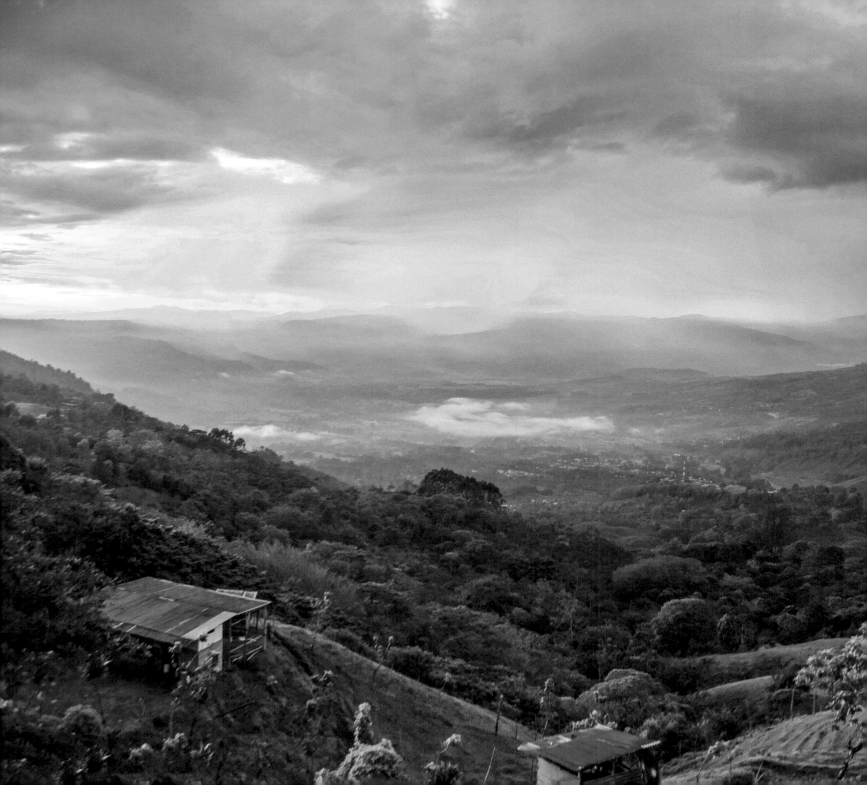

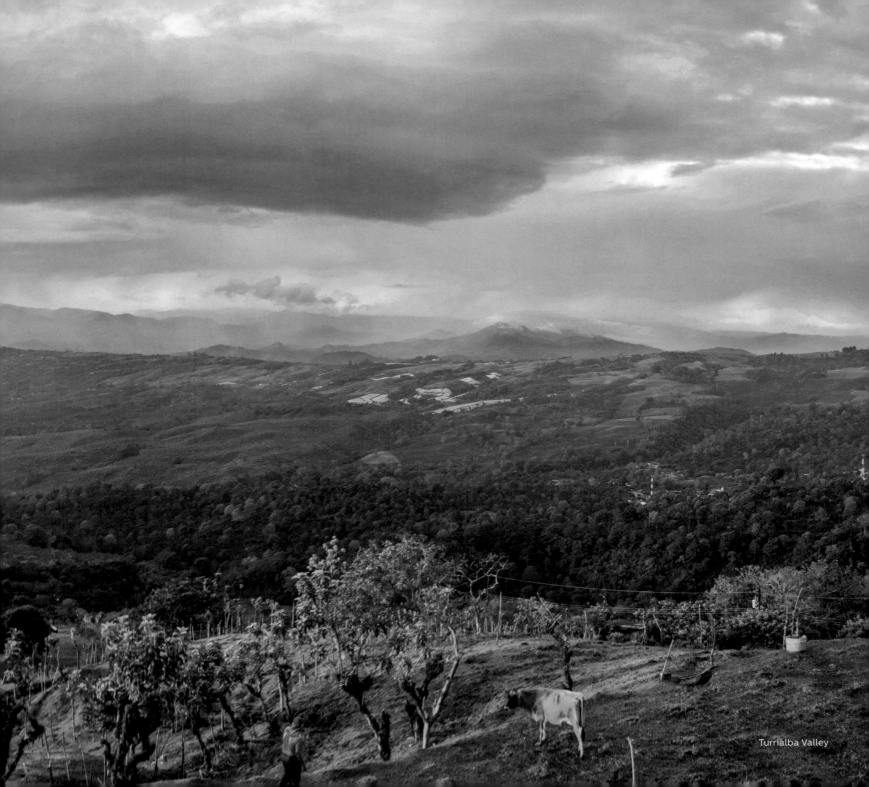

Turrialba Valley

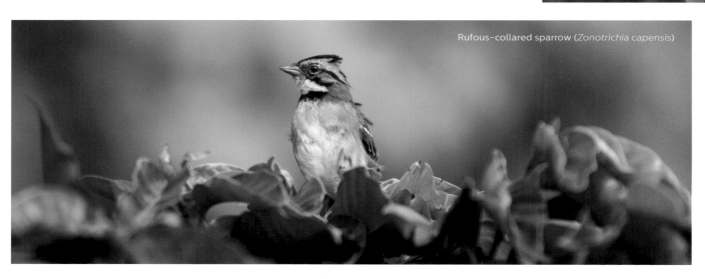

Rufous-collared sparrow (*Zonotrichia capensis*)

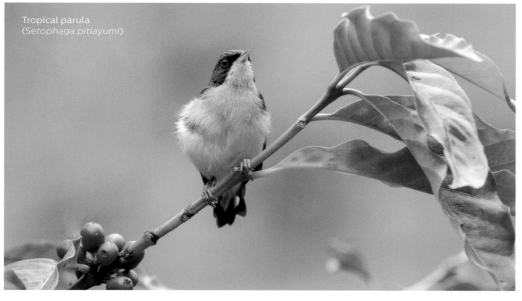

Tropical parula
(*Setophaga pitiayumi*)

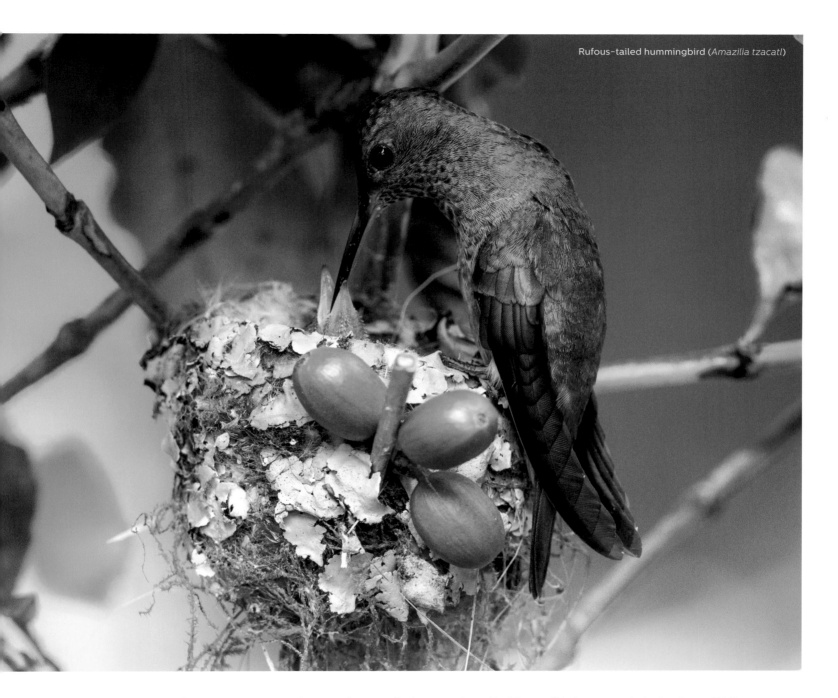

These three species favor open areas, gardens, and, generally, human-altered habitats, all in large supply in the Central Valley.

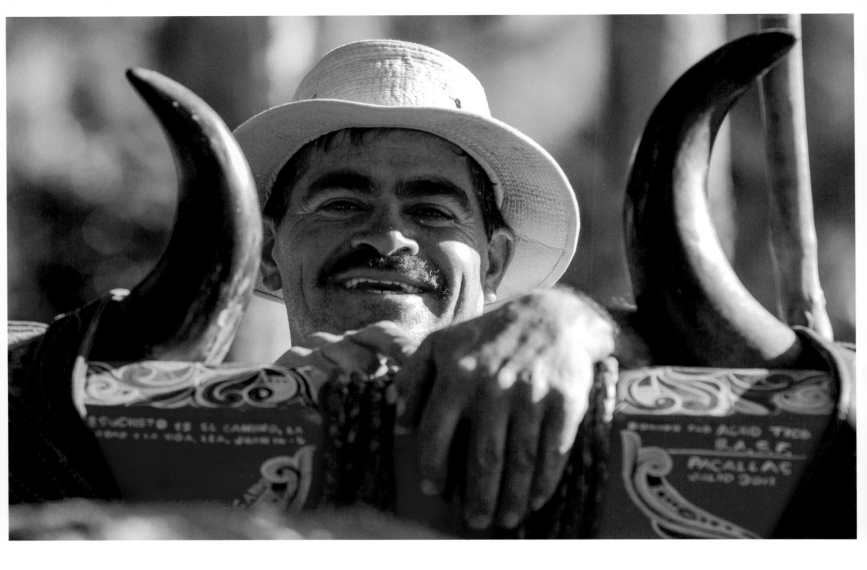

This gentleman with a beatific smile is loading freshly harvested coffee beans onto an oxcart, while his compatriot, above, is harvesting coffee flowers for use in perfumes. In addition to preparing a delicious, hot beverage, the coffee bean and by-products are used to make tea, yes tea (from the husks), as well as fertilizer and air freshener. Increasingly, coffee also features as an ingredient in fusion cooking. One favorite local restaurant, Kalú, offers a delectable appetizer, coffee rubbed salmon, for example.

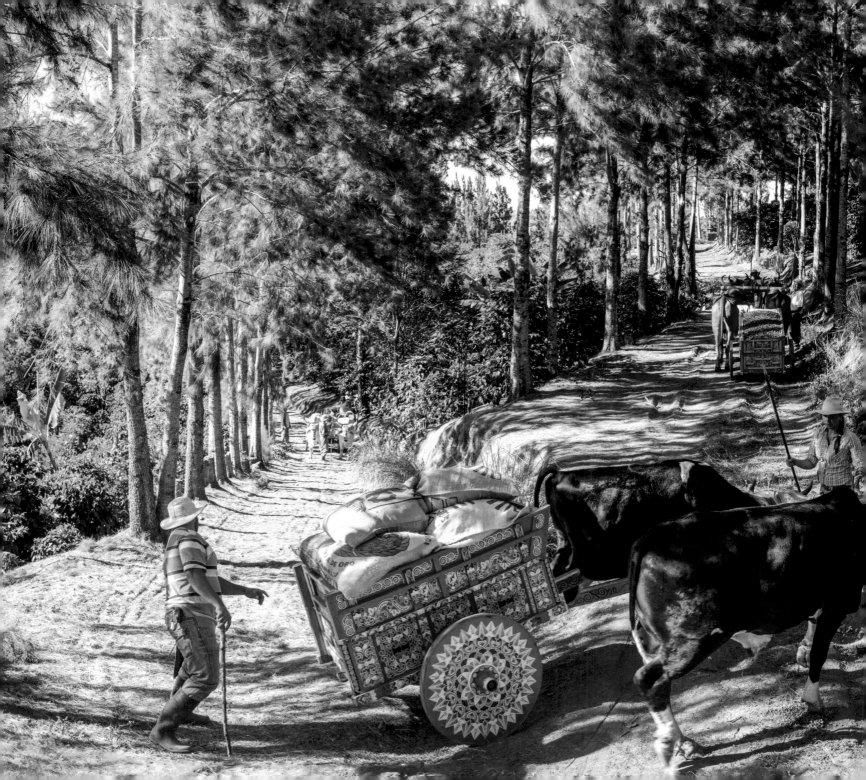

A path in Cartago still traversed by oxcarts.

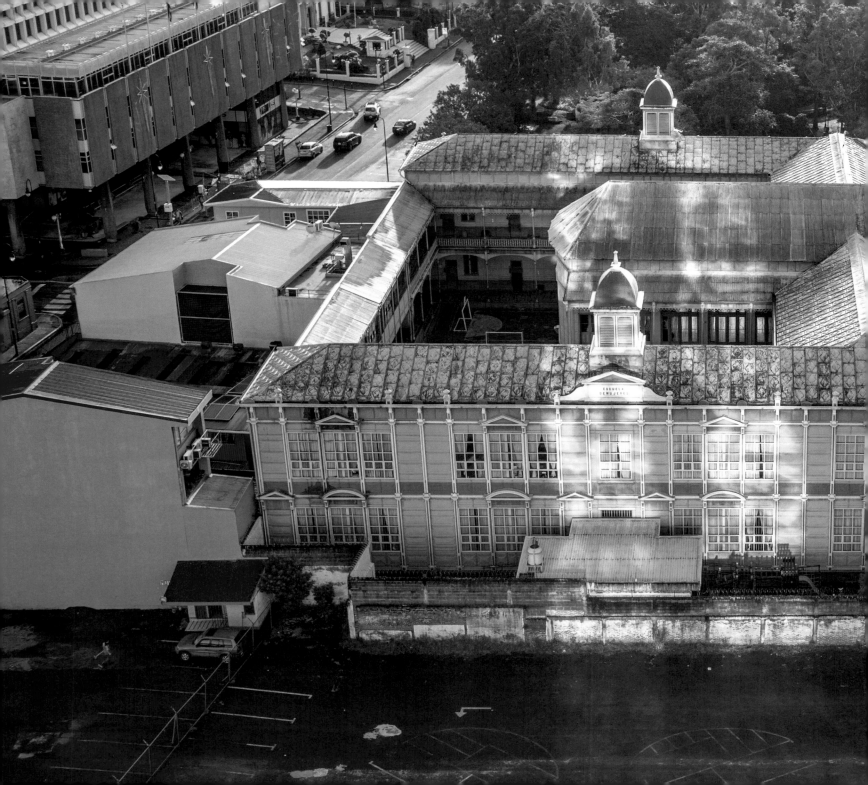

CITIES OF
THE VALLEY

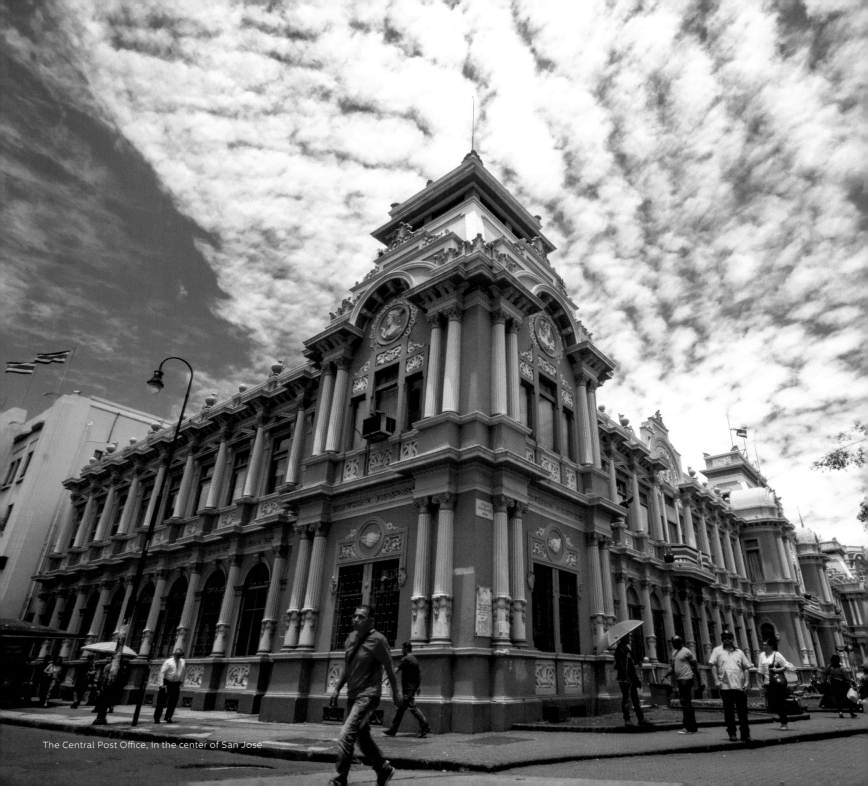

The Central Post Office, in the center of San José

The guide stops and points to the house behind him. Here lived a distinguished Costa Rican citizen in the first years of the 20th century, he says, when this was the wealthiest section of the capital. The group looks around, takes pictures, nods, and continues walking. One block ahead, he relates another story. Again, people lift their cell phones, smile, and murmur in a way that signals nostalgia. It is 7:30 p.m. and twenty or so Costa Ricans are rediscovering the city that their grandparents and great-grandparents inhabited, whose sidewalks they would no longer recognize.

San José is a city that has consigned its past to oblivion. Along its streets, you can see signs of hundreds of buildings that have been demolished, erasing a past architectural charm that still characterizes Central American cities like Granada, Antigua, and Panama City. Despite this, on nighttime walks or daytime strolls through city parks, one senses that there is cultural ferment at work beneath the façade of this seemingly sedate city.

Admittedly, the capital city of Costa Rica was never praised for its architecture, in spite of the best efforts of succeeding generations to spruce it up. The appeal of the place is not due to human hands but rather nature. The first known travel chronicle, published in 1825, states the matter directly: "Villanueva or San José, the capital of the province, is in an extensive valley, or plain, and its location is one of the most beautiful in the world," wrote the Englishman John Hale, who was filled with delight on seeing the giant pasture that would later become La Sabana park.

San José started out modestly enough as a couple dozen houses grouped around a chapel. The Spanish colonists who settled the western part of the valley, or Central Valley, were loath to travel the long distance to Cartago, the capital at that time, preferring instead to attend mass at the nearest indigenous villages. Since that was considered an unwholesome or even unchristian practice in the eyes of the authorities of 1736, the Ecclesiastical Council of León ordered a church to be built closer to home.

Long preceding these events, the Spanish had finished their violent conquest of the valley, having defeated the Huetar kings that once ruled there. The remaining indigenous communities were forced to live within very reduced territories and would be the source of slave labor, which, along with a hospitable climate and fertile volcanic soils, would prove to be "attractive" to colonizers.

Having conquered regions of the valley, the conquistadors radiated out from the provincial capital, Cartago, to extend their holdings, and the native communities fled to the surrounding mountains. Of all the Huetar kingdoms, today only a small community survives in Quitirrisí and Zapatón, in the mountains south of the valley, although their cultural traditions have all but disappeared.

The newly created cities—Villa Vieja (Heredia), Villa Nueva (San José), and Villa Hermosa (Alajuela)—grew slowly, and the verdant valley described by Hale in 1736 would remain much the same until well into the 20th century. These could

be described as garden cities, initially surrounded by virgin forest and later by coffee farms. A week or so after the first rains in May, the coffee fields would be bursting with white flowers, perfuming San José and the other cities.

Indeed, it was the coffee bean that changed the fate of San José, a forgotten city at the periphery of the Spanish lands. With coffee came money and a desire for progress and urban renovation, which is what the liberal elites set out to accomplish around 1870, beginning a transformation that would continue until 1930. This generation had visited the European capitals and wanted to emulate them.

The few buildings that remain from that era are architectural gems, including the Escuela Metálica (1896), the National Theater (1897), the Steinvorth building (1907), the Atlantic Railroad Station (1908), the Central Post Office (1917), the Casa Amarilla (1920), and the Castillo del Moro (1930). Historian Florencia Quesada explains that the capital became the stage for the new educated elite to manifest their nation-state project in a physical space.

The aspirations of the upper class would lead to new neighborhoods northeast of the center of San José—principally Amón and Otoya—in which you can still find some of the nicest old homes in the country, and would influence the design of La Sabana park, modeled after the great parks of Europe and the United States. The elites wanted to have their local version of London's Hyde Park or New York's Central Park.

La Sabana is unlike any other spot in the city, being one of the few public spaces that people of different social classes use. It is common to see families having a picnic on Sundays, lovers sitting by the lake, or executives running on their brief lunch break. Once every two years, when the International Festival of the Arts comes to the city, the park remakes itself and wears its finest clothes.

But at one time the existence of this park came under threat. The government of León Cortés ignored public opinion and inaugurated the "La Sabana" landing field in 1940, in a move that not only did not make sense—on a visit in 1929, the renowned aviator Charles Lindbergh said that the field didn't meet minimum requirements—but that was also, arguably, illegal; opponents of the project argued that the will of Father Chapuí, who donated the land for public recreation, was being violated.

Much later, in 1971, authorities demolished iconic buildings like the former National Library to make space for public parking, while the National Palace was destroyed inexplicably, with no reason given.

As San José expanded and children and grandchildren began to search for houses in the new neighborhoods to the south, north, and east of the capital, only the grandparents remained in the center of San José, clinging to their large family homes. Urban sprawl began to eat up the coffee plantations that once scented the city, with the result that today the greater metropolitan area is home to 60% of the population, 70% of vehicles—all roads lead to San José—and 85% of industry, all within a sliver (4%) of the national territory.

During several centuries, these great transformations—wrought by dreams of a liberal utopia, post-war pragmatism, and a housing boom—would result in a city that fans describe as eclectic and critics say is chaotic. More recently, as people continue to migrate to the suburbs, the city itself has largely become a place for work or to visit.

Central Park, in San José

With the new millennium, something has begun to change in San José. Los Yoses and Escalante, once exclusive neighborhoods that had started to look unkept, were visited by a new generation hungry for urban life and walkable streets. Today, Escalante has dozens of restaurants and bars and hosts art tours (Transitarte) and other cultural events.

Artisanal coffee shops and walk-up windows with Asian or traditional food have started to pop up in old buildings. This new generation, digitally connected to the rest of the world, is yet again trying to create in this city what it envies about other places. Today there are urban cyclist collectives, free museum nights, and jazz concerts and outdoor movie screenings in the dry season, when the pink trumpet trees (*Tabebuia rosea*) begin to flower along Paseo Colón. There are dramatic changes afoot.

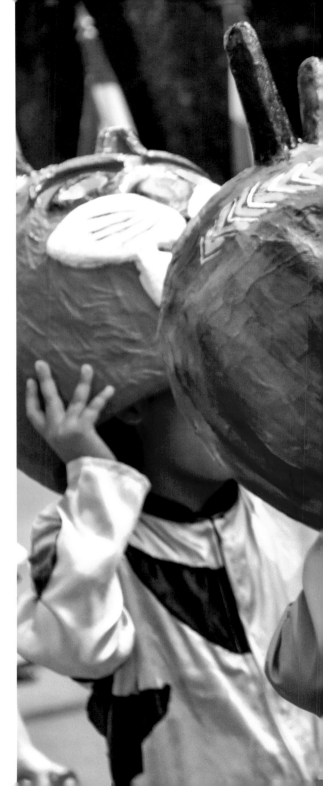

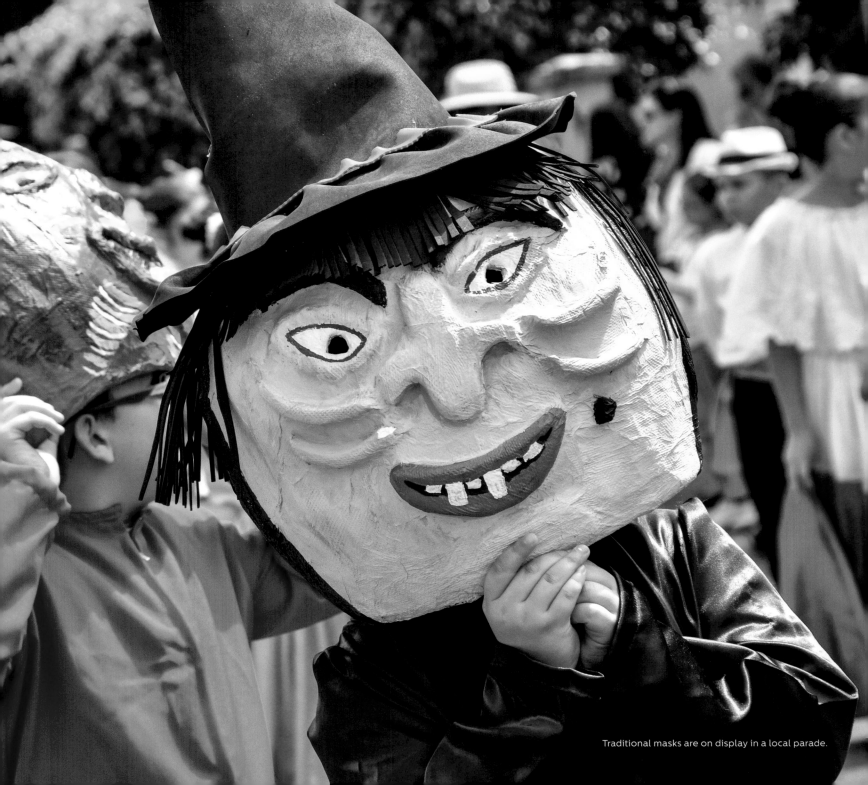

Traditional masks are on display in a local parade.

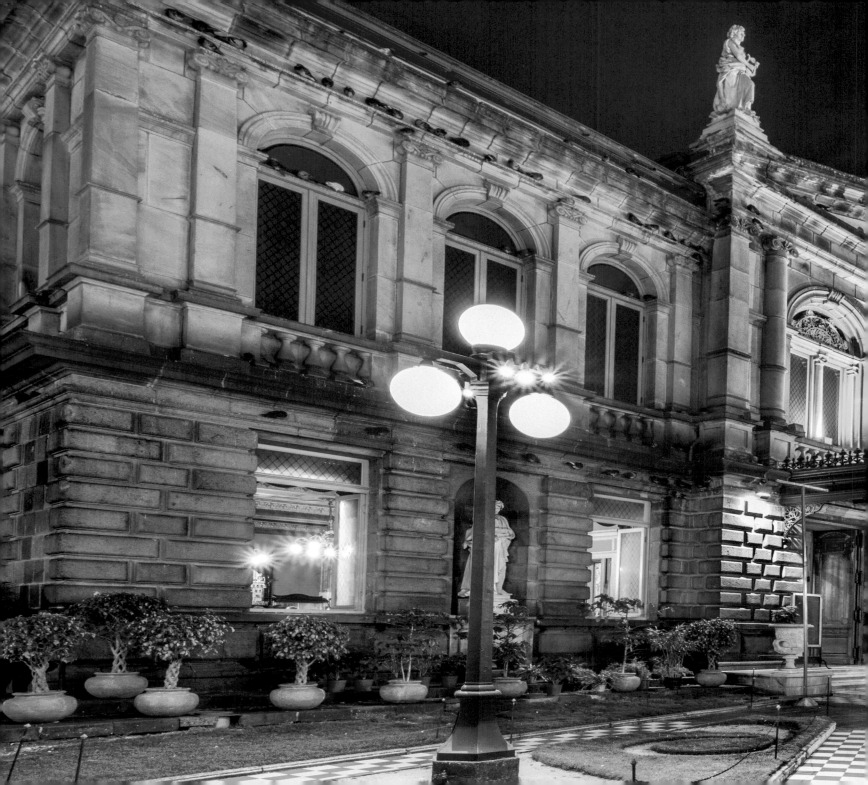

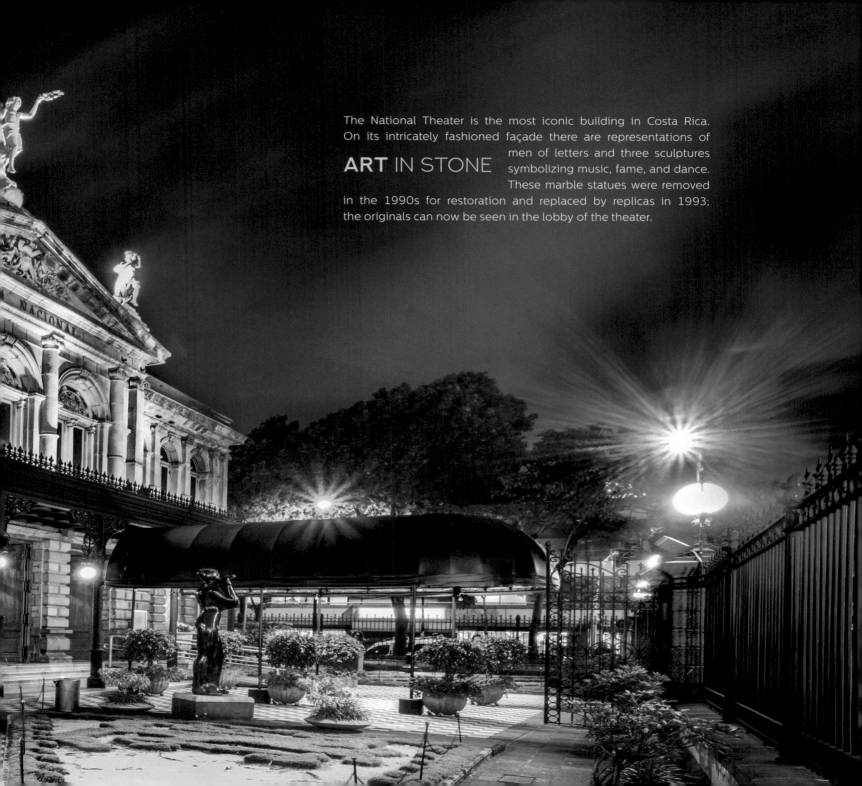

The National Theater is the most iconic building in Costa Rica. On its intricately fashioned façade there are representations of

ART IN STONE

men of letters and three sculptures symbolizing music, fame, and dance. These marble statues were removed in the 1990s for restoration and replaced by replicas in 1993; the originals can now be seen in the lobby of the theater.

DREAMS
OF EUROPE

The National Theater was something of a vanity project, initiated in the 1880s by an economic elite who wished to have access to the charms of the old world at a time when San José had no more than 30,000 inhabitants. The oil painting from 1887 that crowns the main auditorium, called "Allegory of the Arts," attempted to show the connection between the young nation and the fruits of classical European culture. The presidential box, portrayed in the center of this painting, is a reminder to us that the theater was always meant to symbolize the power held by the elites of the country.

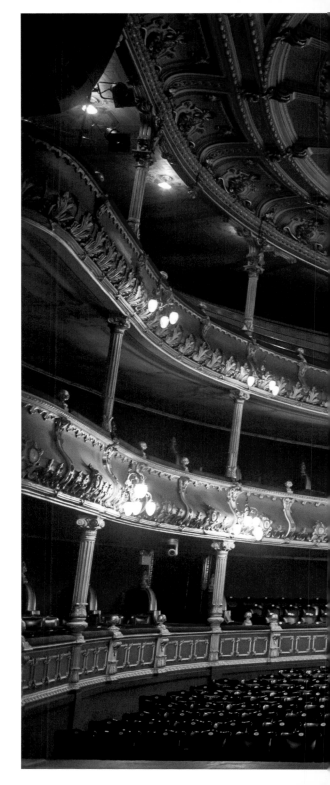

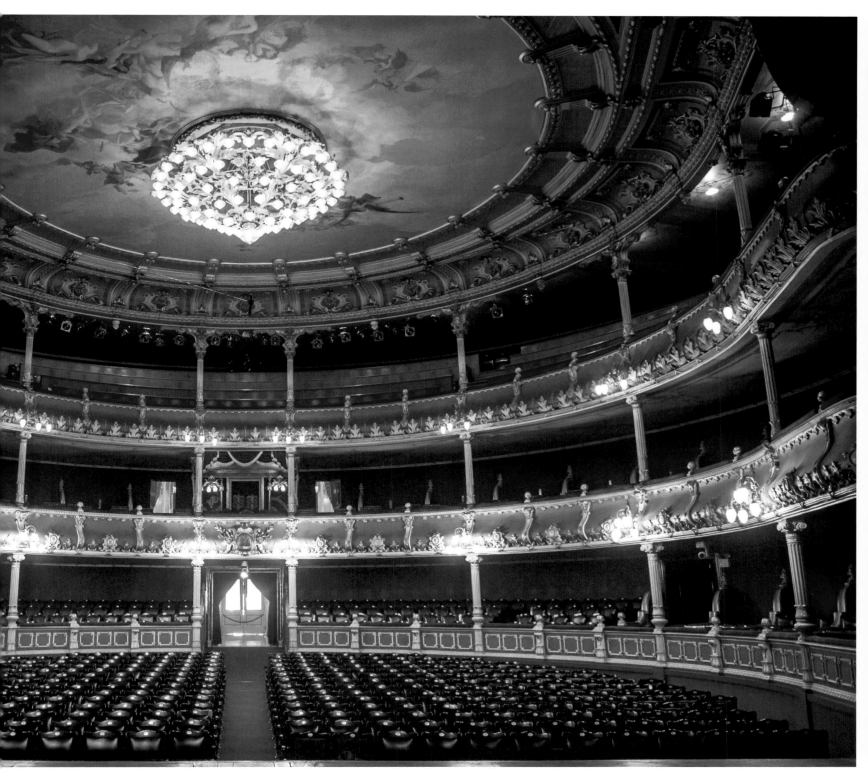

LOST
ARTS

Decade after decade, the mastery of a given trade was passed from teacher to apprentice in the small workshops of San José. With industrialization and globalization, the prospects for this tradition are dim. The remaining craftsmen and traditional merchants still survive amid the side streets of José and in the Central Market.

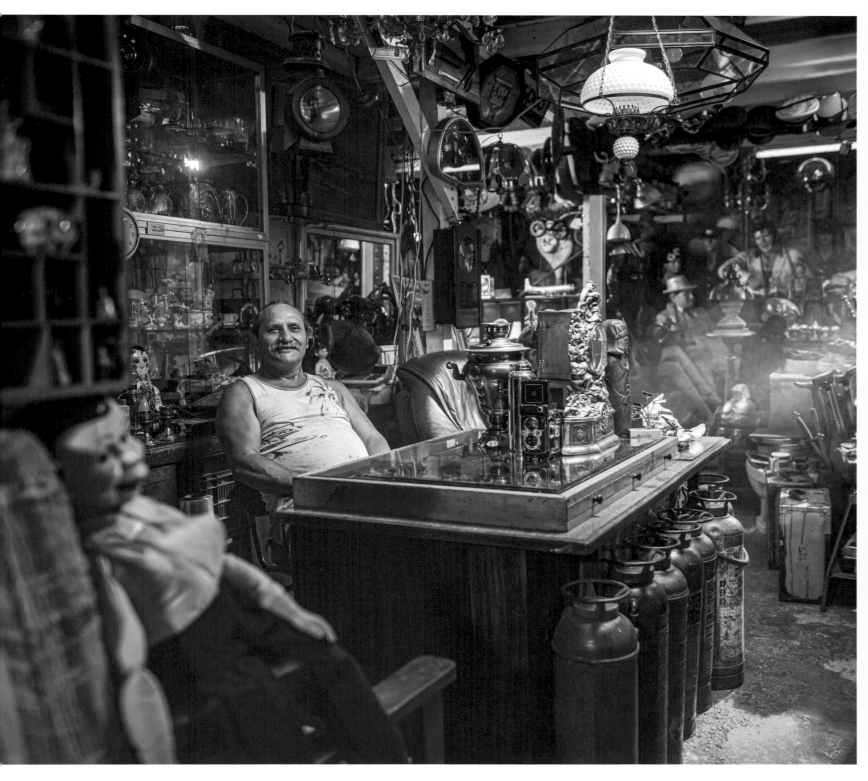

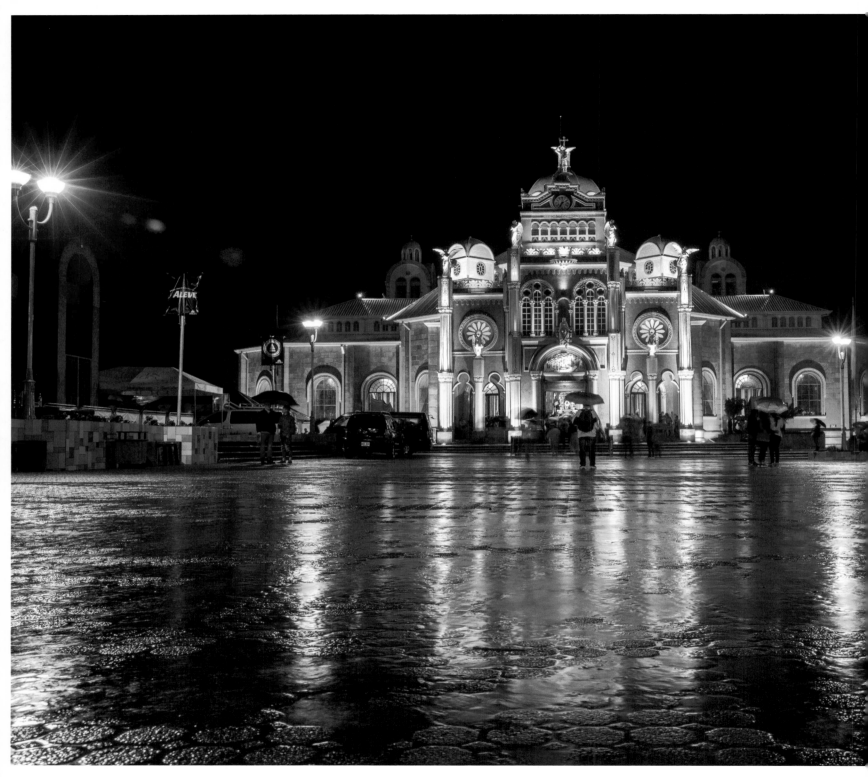

Once a year, the city of Cartago regains the sense of importance it once had when it was the capital of the country. On the first of August, all eyes are on the old metropolis, for this is the day on which the Romería, or Catholic pilgrimage, is celebrated. From around the country, people make the journey on foot to the Basilica of the Angels to pray for the intercession of La Negrita, or Virgin of the Angels.

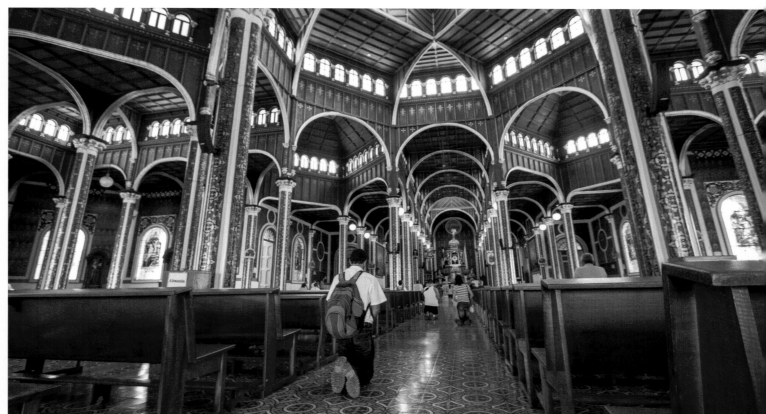

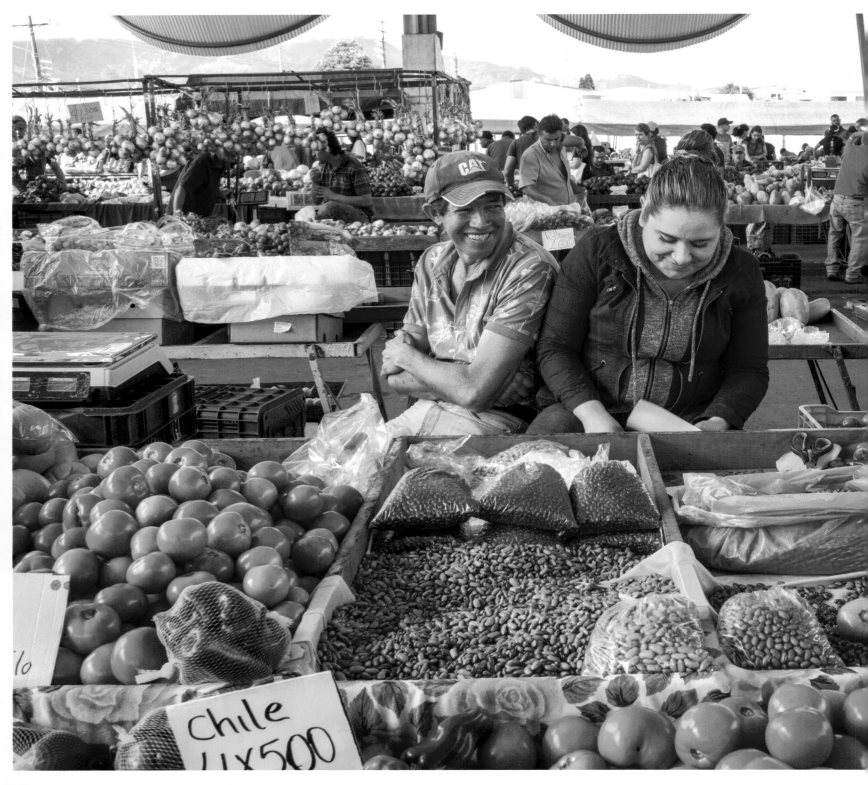

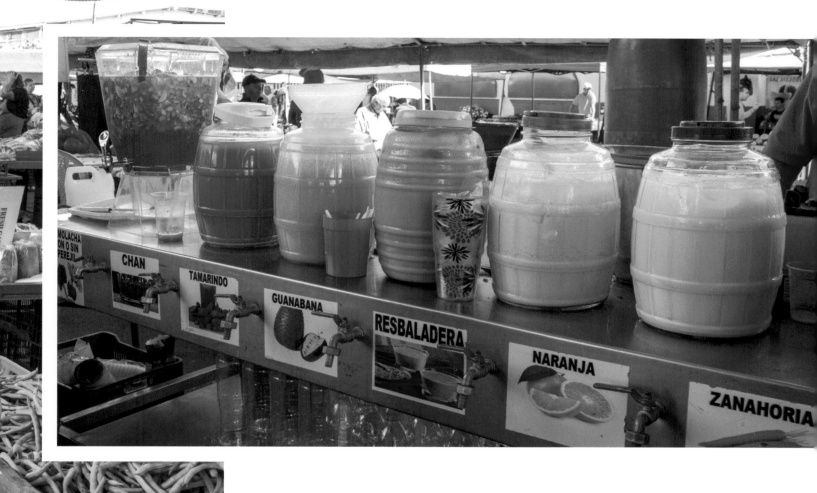

Pungent smells, intense colors, and the shouts of sellers calling attention to their goods characterize local markets, where the goods on display are often of higher quality and at better prices than what can be found in fancy supermarkets.

105

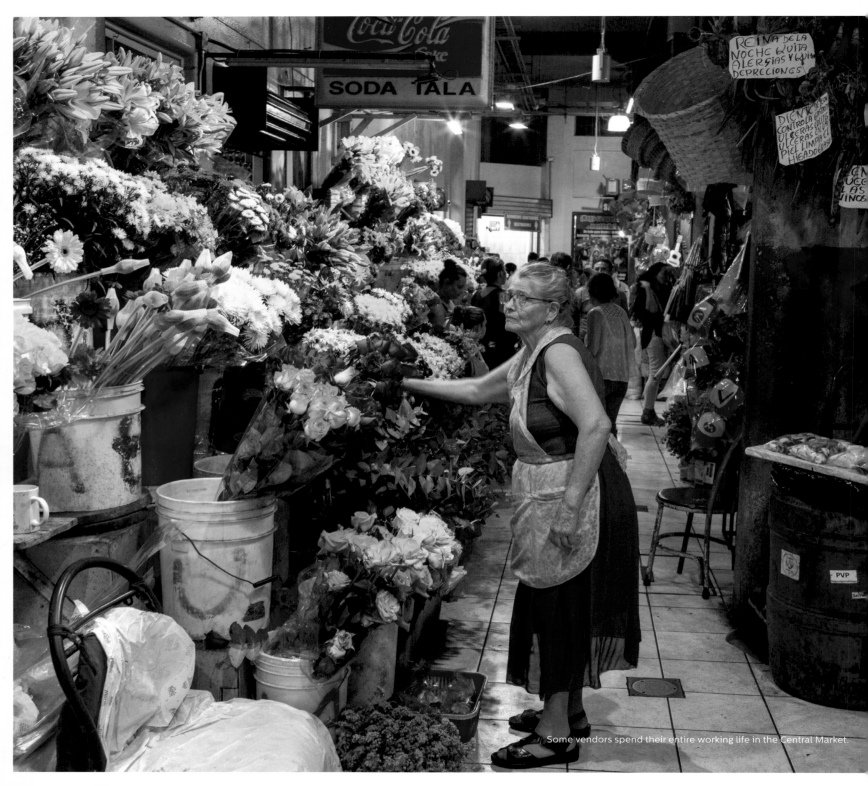

Some vendors spend their entire working life in the Central Market.

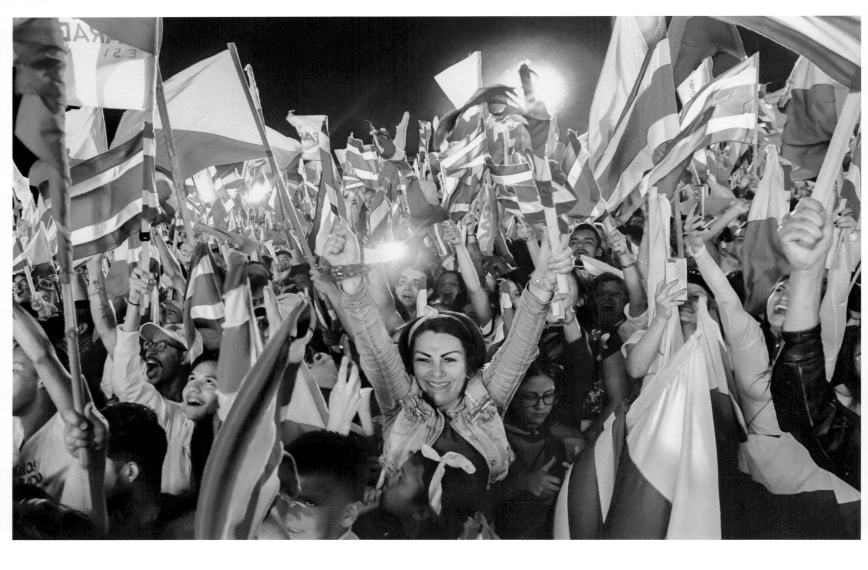

The atmosphere surrounding elections in Costa Rica displays a tenor virtually unique to Latin America. Whether this is due to a history free of armed conflict, the "national character," or high levels of social equality, is difficult to say. For whatever reason, on election day, at ballot boxes, in the streets, or amid evening celebrations, the overall tone is affable and—on the part of the winners—cheerful.

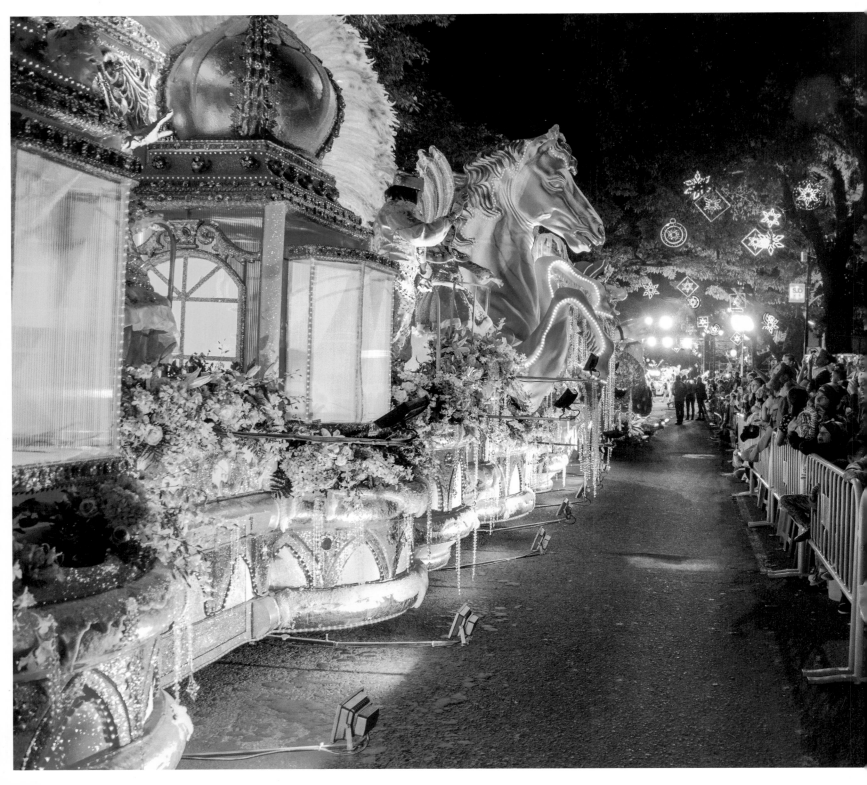

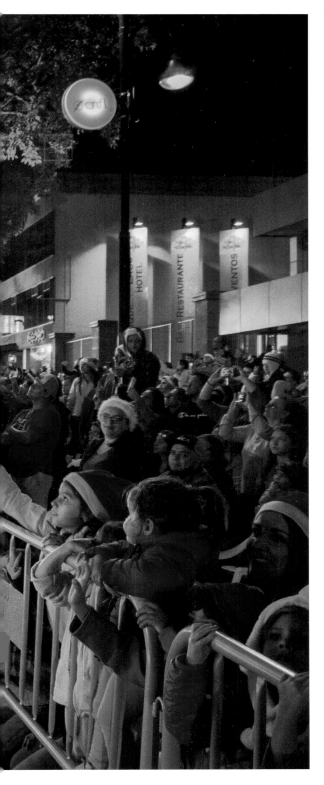

MAGICAL
LIGHTS

Once a year, the traffic jams and honking horns on the main arteries of San José give way to magic. Since 1996, the Festival of Light has attracted tens of thousands of Costa Ricans to the heart of the capital to witness the parade of floats and orchestras. This celebration, which takes place toward the middle of December, kicks off the Christmas season in the capital.

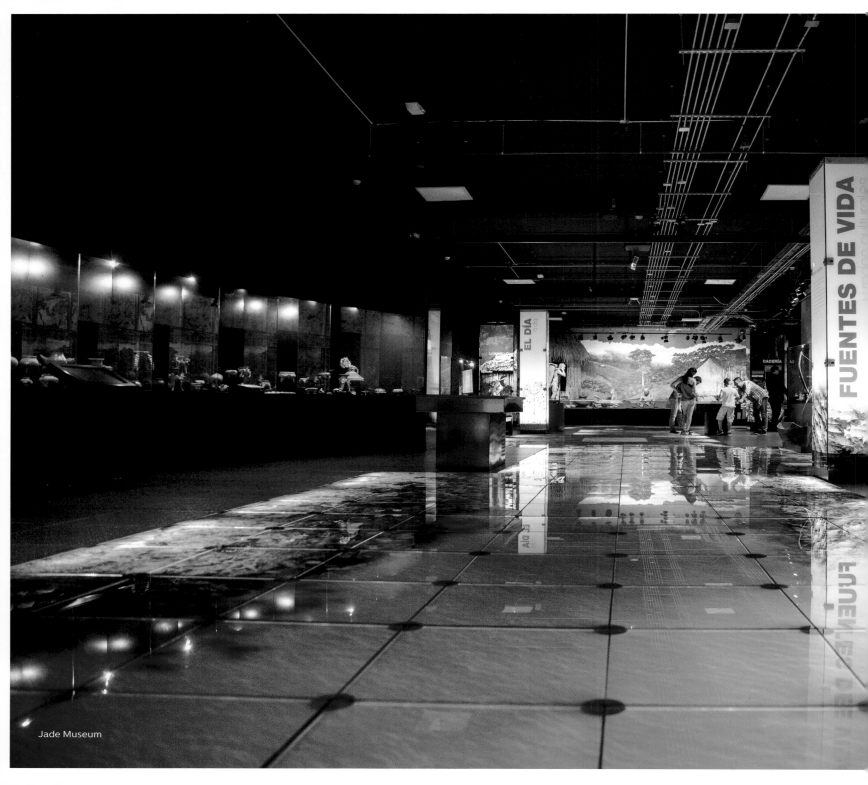

Jade Museum

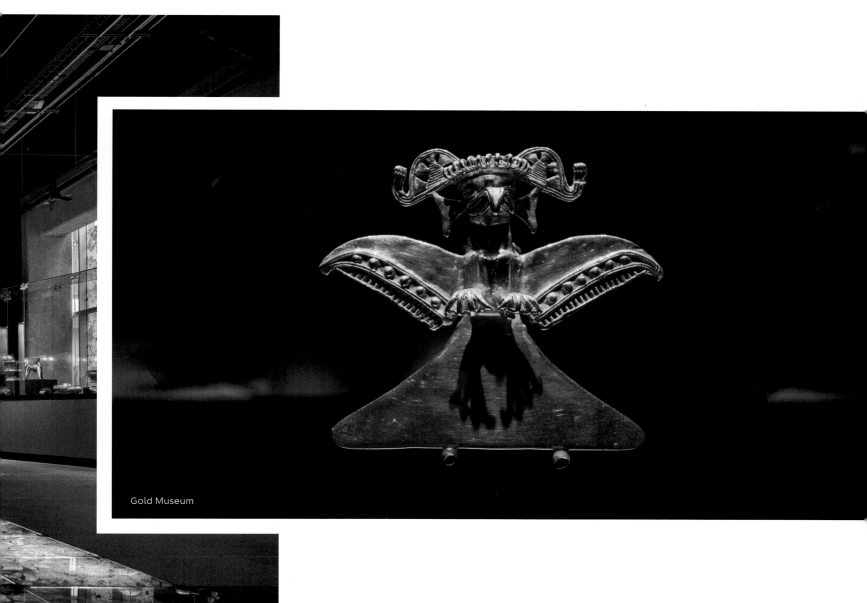

Gold Museum

The Museum of Jade and Pre-Columbian Culture, located in San José, has almost 7,000 archaeological pieces, including the largest collection of jade artefacts in the world. A few blocks to the west is the Pre-Columbian Gold Museum.

In the center of Morazán Park stands the Temple of Music, which was inaugurated in 1920. It is nearly an exact replica of a similar structure located in the Palace of Versailles, in France. Nearby is the Metallic School, whose design is often erroneously ascribed to Gustave Eiffel.

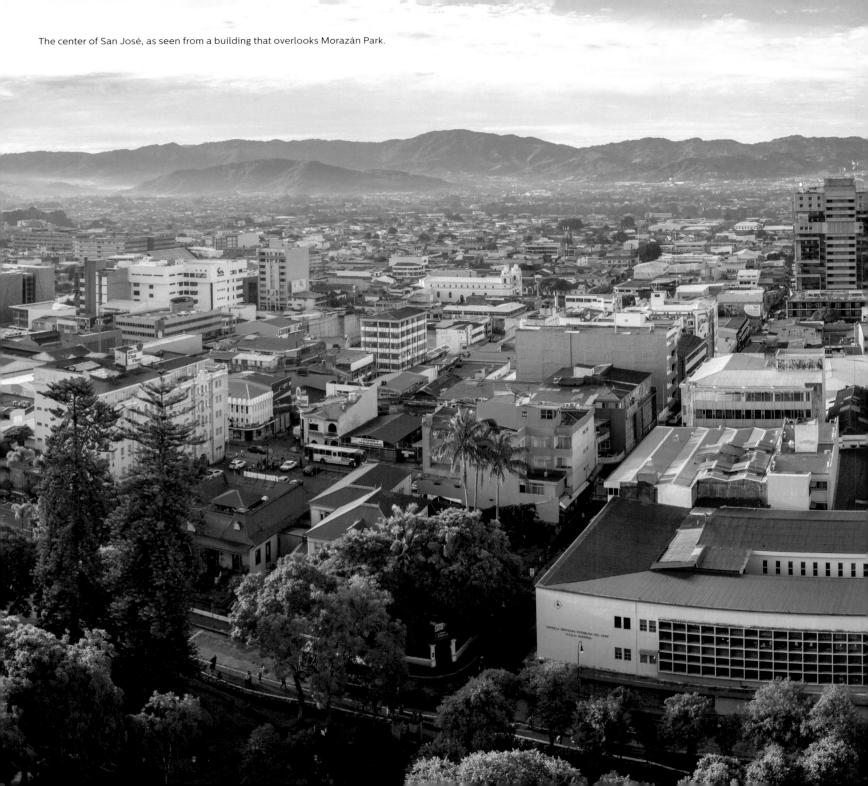

The center of San José, as seen from a building that overlooks Morazán Park.

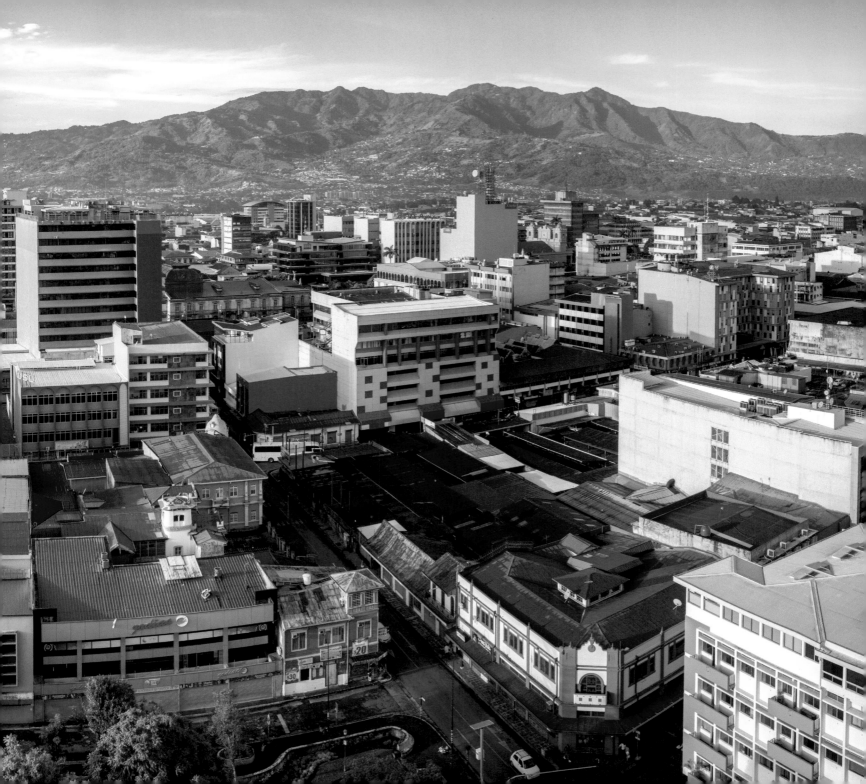

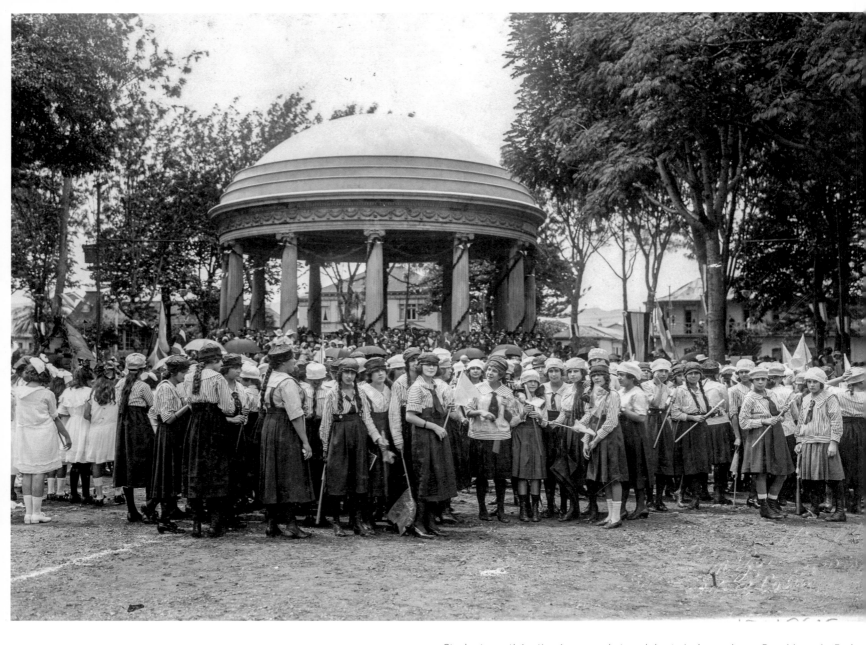

Students participating in a parade to celebrate Independence Day, Morazán Park.

INDEX

A
Alajuela — 3, 51
Allegory of Coffee and Bananas — 55
Amazilia tzacatl — 81
Amón (neighborhood) — 91
Aquiares farm — 70
Aserrí — 52, 53, 55
Atlantic Railroad Station — 91

B
Barva Volcano — 5, 7
Basilica of the Angels — 103
bellbird — 45
Black-billed nightingale thrush — 17
Botos people — 5
Boza, Mario — 3, 7
buffy-crowned wood-partridge — 43

C
cajuela — 67
Campylopterus hemileucurus — 6
Caribbean coast — 59
Carrillo, Braulio — 52
Cartago — 5, 13, 51, 52, 59, 85, 90, 103
Casa Amarilla — 91
Castillo del Moro — 91
Catharus gracilirostris — 17
Central Market — 100, 106
Central Mountain Range — 7
Central Park — 91
Central Post Office — 88, 91
coffee plant — 51
collared redstart — 16, 17
Compañia Itinerante — 52
Cortés, León — 92
Costa Rican
 Tourism Institute (ICT) — 3, 4

D
Dendrortyx leucophrys — 43
Dent (neighborhood) — 56
Doka coffee farm — 63

E
elegant euphonia — 30, 31
emerald glass frog — 37, 42
Escalante (neighborhood) — 56, 94
Escuela Metálica
 (Metallic School) — 91, 115
Espadarana prosoblepon — 37, 42
Euphonia elegantissima — 31
Eurypyga helias — 21

F
Father Chapuí — 92
Fernández Hidalgo, Santiago — 52
Festival of Light — 111

G
gesneriad flower — 6
Gnäbe indigenous community — 69
Gold Museum — 113
golden bean — 52
grano de oro — 52
Guayabo National Monument — 19, 20
Gulf of Nicoya — 10

H
Hacienda Juan Viñas — 59
Hale, John — 89
hercules beetle — 42
Heredia — 51
Huetar kings — 90

I
International Festival
 of the Arts — 92
Irazú Volcano — 2, 4, 5, 7, 8, 10, 13, 23, 28, 47
Irazú Volcano National Park — 25

J
Jade Museum — 112
Juan Castro Blanco National Park — 6

K
keel-billed toucan — 20
Kennedy, John F. — 5

L
La Negrita — 103
La Sabana park — 89, 91, 92
Leopardus wiedii — 41
Llano Bonito de Tarrazú — 64
Los Yoses (neighborhood) — 4

M
margay — 41
Metallic School
 (Escuela Metálica) — 91, 115
Mora Fernández, Juan — 52
Morazán Park — 115, 116
Museum of Contemporary Art — V
Myioborus miniatus — 16

N
National Library — 92
National Palace — 92
National Parks Department — 3
National Theater — 53, 91, 97, 98

O

oak trees 38
Obregón Loría, Manuel 4
orange-bellied trogon 30
Otoya (neighborhood) 91

P

Paseo Colón 94
Pérez-Ratton, Virginia V
Pharomachrus mocinno 25
pink trumpet tree 94
Pittier, Henri 4
Poás (town) 53
Poás Volcano 3, 4, 5, 7, 9, 33
Poás Volcano cráter 25, 27
Poás Volcano National Park 3
Pre-Columbian era 5
Procnias tricarunculatus 45
Prusia Forest Reserve 25
Puntarenas 52

Q

Quesada, Florencia 91
Quitirrisí 90

R

railroad 59
Rainforest Alliance certification 70
Ramphastos sulfuratus 20
resplendent quetzal 25
Romería 103
rufous-collared sparrow 80
rufous-tailed hummingbird 81

S

Sabanilla de Alajuela 63
San Ramón 53, 55
San José V, 4, 5, 7, 25, 51, 52, 53, 56, 59, 89, 90, 91, 92, 94, 98, 116, 117
San Marcos de Tarrazú 72
Santa Eduviges 63
Santa Rosa National Park 7
Santo Domingo 55
scarab beetle 36
Scarabaeidae 36
scintillant hummingbird 34
Selasphorus flammula 64
Selasphorus scintilla 34
Setophaga pitiayumi 80
Spanish Empire 51
Steinvorth building 91
sunbittern 21

T

Tabebuia rosea 94
Temple of Music 115
TEOR/éTica V
Transitarte 94
Tres Ríos 52, 53
Trogon aurantiiventris 30
tropical parula 80
Turrialba 70
Turrialba Valley 59, 79
Turrialba Volcano 5, 15

U

Ugalde, Álvaro 7, 9
Ujarrás 55

V

Villa Hermosa (Alajuela) 90
Villa Nueva (San José) 90
Villa Vieja (Heredia) 90
violet sabrewing 6
Virgin of the Angels 103
volcano hummingbird 64

Z

Zapatón 90
Zonotrichia capensis 80

CREDITS

PHOTOGRAPHERS

Unless indicated below, all photographs
are by Luciano Capelli.
Gregory Basco: pp. 6, 34, 35, 36, 37, 38, 40, 42 (top), 42 (down)
Ezequiel Becerra: pp. 95, 96, 97, 108, 110, 111
Mauro Quirós: pp. 88, 90, 91, 93, 102, 103, 112, 113
Jorge Chinchilla: pp. 13, 16, 30, 31, 43, 44
Fausto Fabbri: pp. 104, 105, 106, 107
Eloy Mora: pp. 100, 10
Esteban Chinchilla: pp. 98, 99
Nick Hawkins: pp. 32, 39
Pepe Manzanilla: pp. 20, 21
Alexandra Pérez Johnston: p. IV
Alvaro Cubero: p. 24
Francisco Coto: p. 2
José Pablo García: p. 109
Manuel Gómez Miralles: p. 50

COVER PHOTOS

Luciano Capelli,
Jeffrey Muñoz

LAYOUT DESIGN & PHOTO RETOUCHING

Francilena Carranza

LOGO, MAP & ILLUSTRATIONS

Elizabeth Argüello

ORIGINAL TEXT

Diego Arguedas Ortiz

ENGLISH ADAPTATION

Noelia Solano,
John Kelley McCuen

TEXT REVIEW

John Kelley McCuen,
Stephanie Monterrosa

CONCEPT

Luciano Capelli,
Stephanie Monterrosa,
John Kelley McCuen

PRODUCTION

Luciano Capelli,
John Kelley McCuen
Stephanie Monterrosa

ABOUT
THE
PUBLISHERS
—

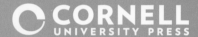

Cornell University Press fosters a culture of broad and sustained inquiry through the publication of scholarship that is engaged, influential, and of lasting significance. Works published under its imprints reflect a commitment to excellence through rigorous evaluation, skillful editing, thoughtful design, strategic marketing, and global outreach. The Comstock Publishing Associates imprint features a distinguished program in the life sciences (including trade and scholarly books in ornithology, botany, entomology, herpetology, environmental studies, and natural history).

Ojalá publishes illustrated books about the biodiversity and cultural identity of Costa Rica. With every title, we strive to intertwine images and text to transport readers on a voyage through this extraordinary country.

Zona Tropical Press publishes nature field guides and photography books about Costa Rica and other tropical countries. It also produces a range of other products about the natural world, including posters, books for kids, and souvenirs.

COSTA RICA ≈ REGIONAL GUIDES

GUANACASTE

MARÍA MONTERO AND LUCIANO CAPELLI

MONTEVERDE & ARENAL

MARÍA MONTERO AND LUCIANO CAPELLI

CARIBBEAN COAST

YAZMÍN ROSS AND LUCIANO CAPELLI

MANUEL ANTONIO BALLENA & CARARA

DIEGO ARGUEDAS AND LUCIANO CAPELLI

OSA & SOUTH PACIFIC

DIEGO ARGUEDAS AND LUCIANO CAPELLI

CENTRAL VALLEY

DIEGO ARGUEDAS AND LUCIANO CAPELLI

Principal font: Centrale Sans